PAST & PRESENT

APPLE VALLEY

APPLE VALLEY

Michelle Lovato

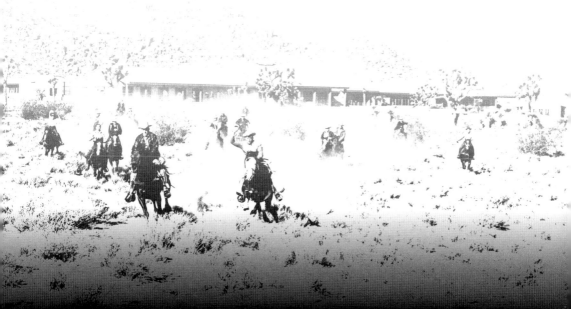

Without COVID 19, I would never have met Marcella L. Taylor, founder of the Apple Valley and Victor Valley Legacy Museums. Without Marcy Taylor, I would never have completed this book. Cliché as it may seem, Marcy Taylor was this book's linchpin person who set her own life aside to help a stranger succeed. She is now a dear friend. Thank you.

Library of Congress Control Number: 2021943578

Published by Arcadia Publishing
Charleston, South Carolina

Printed in the United States of America

For all general information, please contact Arcadia Publishing:
Telephone 843-853-2070
Fax 843-853-0044
E-mail sales@arcadiapublishing.com
For customer service and orders:
Toll-Free 1-888-313-2665

Visit us on the Internet at www.arcadiapublishing.com

ON THE COVER: Scarred with time and weather, the Apple Valley Inn, featured in this photograph, is arguably the most famous building on the desert. The inn was a western resort with the highest-quality modern conveniences available in its heyday. The inn served as home base for countless movie shoots, publicity photographs, and Hollywood superstar respites. Opened in 1949, the inn continues to serve Apple Valley, the desert, and Hollywood today. (Courtesy of Town of Apple Valley.)

ON THE BACK COVER: Apple Valley developers Newton T. Bass and brother-in-law Bud Westlund's success was magnified by their genius, out-of-the-box marketing programs. Their real estate development empire, Apple Valley Ranchos, had offices with salesmen available 24-7 in Beverly Hills, Hollywood, Long Beach, and on Main Street in Disneyland. This billboard, likely in Long Beach, was one of many used to lure residents and businesses to the area. (Courtesy of Town of Apple Valley.)

CONTENTS

ACKNOWLEDGMENTS

I would like to thank Marcy Taylor, the Mohahve Historical Society, its board and its volunteers, the Apple Valley Legacy Museum volunteer team, Town of Apple Valley, Lena Quinonez, Donna Pierson, Diane Irwin, Fran Elgin, Bruce Hollenbeck, the family of John Bascom, my mother, children, and a host of pioneer family members who were kind enough to befriend me. This book chronicles a tiny piece of our collective story. I did my best to be accurate with the present photographs, so please forgive me if I missed an angle, fact, or location. Writing this book, walking the ground memorialized before me, was like watching ghosts rise out of the desert and highlight the joy they captured in life. Thank you, past Apple Valley residents. Your story is inspiring and unforgettable.

All present images are courtesy of the author's collection and that of Marcy Taylor at the Apple Valley Legacy Museum.

INTRODUCTION

Apple Valley, California, this place of dirt, wind, and death, continues to rejuvenate itself into vibrant life through creative marketing, out-of-the-box thinking, and sheer determination. What looked like a vast, angry expanse of nothing 150 years ago, an unforgiving, leather-skinned place where few men dared to wander, is now a booming senior citizens' mecca, an upper-class real estate enclave, an equestrian-centric town, and a logistics hub brimming with life and future.

Ironically, the same forward-moving drive for innovation that townspeople used to build their later empires also helped repurpose eras of previous growth that rose and fell before it.

Apple Valley's earliest developers were orchardists and ranchmen. Early farmers raised cattle, grew acres of luscious award-winning and highly sought-after fruit, developed business alliances with wealthy buyers, and promoted Apple Valley for others to experience and enjoy.

But according to longtime resident Mareta Westphal, the need for soldiers during World War I drew most able-bodied young men out of the area, and the implementation of a far less financially efficient electric water pumping system replaced the standard gas-driven irrigation pump.

After the war, even those who did come home to their beautiful mesa were faced with an electric bill that made it impossible to continue farming.

The era of guest and dude ranches was born.

The idea of using the desert's dry climate for health purposes was nothing new. Several health farms were already in operation, but many more landowners took up the guest ranch idea.

Apple Valley landowners offered authentic experiences for those seeking a healthy environment or respite from their hectic Los Angeles life.

Though history books are quick to point out the dozens of world-famous celebrities who spent months and years at the Yucca Loma Guest Ranch, the area was brimming with a wide range of getaways perfect for anybody, regardless of their income or race.

What began in the 1920s as a health ranch for people of all races, the Murray Overall Wearing Dude Ranch later busted racial boundaries when it opened the world's first-ever dude ranch that welcomed black people, as well as anyone of any other color. Black owned and operated, the Murray Overall Wearing Dude Ranch caught the attention of the working class and specifically those union workers who read working-class union-worker magazines, where Lela Murray said her advertising was most successful.

The McCarthy Ranch, which began in south Apple Valley on land that is now a mass of housing complexes, started as one ranch owned by a married couple. But according to *Victor Valley News* reporter Wally Gould, the desert-loving team could not agree on how to run the ranch. Irene wanted the ranch to be a place of relaxation, while Mac wanted it to be a tougher, working dude ranch. The answer was divorce, and two McCarthy ranches, with one located at the south end for resting and one at the northeast end for "the reward of a hard day's work," according to Gould, who quoted Mac himself.

Just as World War II began draining Apple Valley's youth once more, Newton T. Bass, a Long Beach entrepreneur, and his partner Bud Westlund arrived and purchased 22,000 acres of land and laid out a 600-acre townsite, according to an Apple Valley Ranchos history story printed in the local newspaper.

Bass and Westlund would transform the ranching community into a town with a twist, one that offered the most up-to-date conveniences, along with an equestrian-friendly layout. Thanks to Bass and Westlund, residents could leave the modern conveniences of their sprawling ranch homes and ride their horses to town when they needed milk.

The new Bass/Westlund town had a dance hall, restaurants, gift shops, and a grocery store, which was rumored at one time to be owned by *King Kong* lead actress Fay Raye, though no records show this as fact.

The two men built an empire like no other in the desert and drew wealthy speculators and businessmen, celebrities, and horse lovers to the area. Bass brought luxury to Apple Valley and is known as the town's founder, even though Westlund was the partner who possessed deep pockets. Era after era passed as those whom Bass romanced to the area fell in love with Apple Valley and made it their lifelong home. A library, schools, a community center, post office, water company, chamber of commerce, and sheriff's posse developed as a mass of hardworking Apple Valley residents built on the Bass/Westlund dream and created a community.

People square danced; held parades, barbecues, and community get-togethers; and attended Sunday school.

For 50 years, the Bass-driven town of Apple Valley continued to grow, and on November 28, 1988, Apple Valley finally became an official "town." The city was too citified for Apple Valley. It wanted to be a town to preserve its identity as an easy, relaxing, meandering, equestrian-friendly place.

Today, an Apple Valley resident can leave the modern conveniences of his own home and ride his horse to town. There are no more hitching posts, like the one outside the Double R Tradin' Post, but horsemen can amble the same paths Bass built and enjoy the ever-changing, ever-fascinating desert so many ambled before.

Today's political and administrative leaders are developing a massive warehouse and distribution hub in the north Apple Valley desert, along with a state-of-the-art, high-speed rail system to transport travelers between population-intense Southern California and the Las Vegas playground. The new Apple Valley railroad station vision is approachable, thanks to a late-1800s rail spur originally intended to connect San Diego and Barstow for commercial reasons but was abandoned in Apple Valley after the railroad company was sold and another, more lucrative route to Barstow was developed elsewhere. The late-1800s rail spur is conveniently located next to the heavily traveled I-15 freeway connecting Southern California to the High Desert and beyond across the country.

In the distance, a few remnants of settlers, orchardists, and ranchers still stand. As layers of history are eventually capped by time and progress, those remnants will be gone—but not forgotten.

TAMING THE WEST

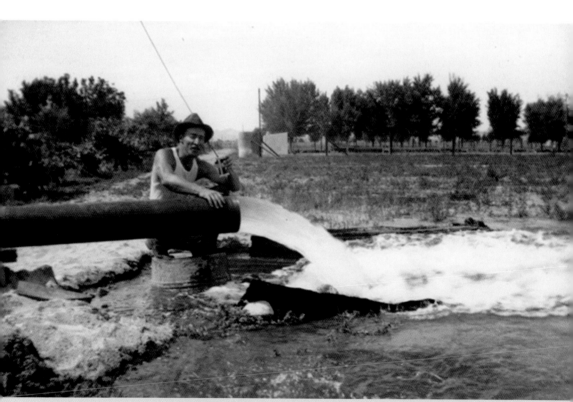

Apple Valley pioneer Stoddard Jess sips a cool drink while sitting next to the water pipe that pours precious life onto his land. Jess is one of the Mojave Desert's most successful entrepreneurs, and his family continues to live on what is left of the Jess Ranch today. (Courtesy of Stoddard Jess family.)

Founding pioneers Dr. Harrison Garcelon (left) and orchardist William Harris (right) stand together under a Joshua tree near Deep Creek Road. Dated 1910, this image shows Garcelon holding what appears to be a doctor's kit, while Harris is showing off his trusty rifle. According to an article by *Daily Press* founder John Barry, the A.W. Phillips property was located between Bear Valley, Deep Creek, and Apple Valley Roads. The Joshua tree stands today on the property of an occupied Deep Creek Road home. The Harris Garcelon property was located directly west of the Phillips property and was commonly known as a "showplace." Garcelon was known as "establishing one of the area's first guest ranches," according to the Barry article. Garcelon's property was sold to Stoddard Jess, Garcelon's nephew, whose ranch continues to be in existence today. (Past image, courtesy of Stoddard Jess family.)

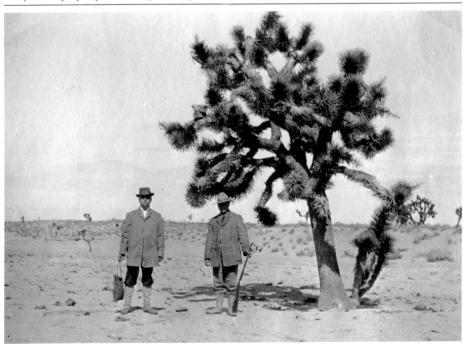

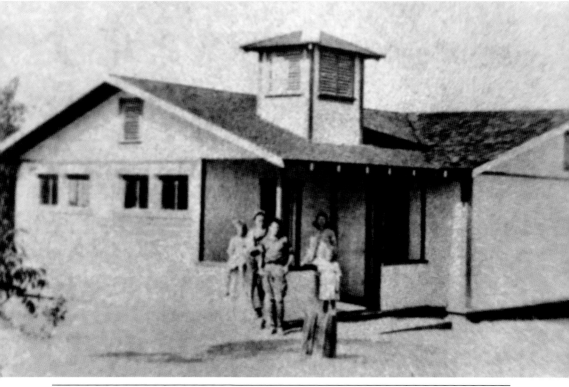

This photograph is believed to show Apple Valley's first school, but some disagree about where it was taken. The John Carrol family donated land for the first school site at the southeast corner of Deep Creek and Rock Springs Roads, where the stone foundation still stands. The school was later moved to its second home at the southeast corner of Bear Valley and Deep Creek Roads. In 1910, a second school was built near Bell Mountain. (Past image, courtesy of Mohahve Historical Society.)

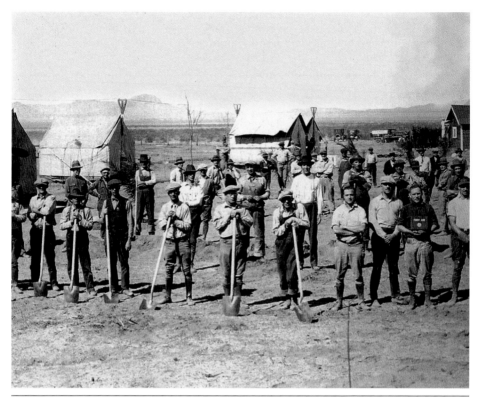

The Lone Wolf Colony, located on the east end of Bear Valley Road, was owned and developed by telephone company employees. Established in 1922 and still in operation today, this site is used as a health ranch for adults recovering from injuries, surgeries, and noncommunicable diseases. Telephone employees paid for the construction, upkeep, and services with donations from their paychecks, and the facility was intended to serve its employee membership. (Past image, courtesy of Town of Apple Valley.)

The Hitchcock Farm, located at the southwest corner of Highway 18 and Navajo Road, was an important winter ranching outpost for partners Edwin Grimes and William W. Hitchcock, whose summer ranch existed near Big Bear. Hitchcock owned large swaths of land along the well-worn trail from Big Bear that is now known as Highway 18. The Hitchcock's location was central to the founding town fathers, who later created a lasting municipality that continues to thrive today. (Past image, courtesy of Town of Apple Valley.)

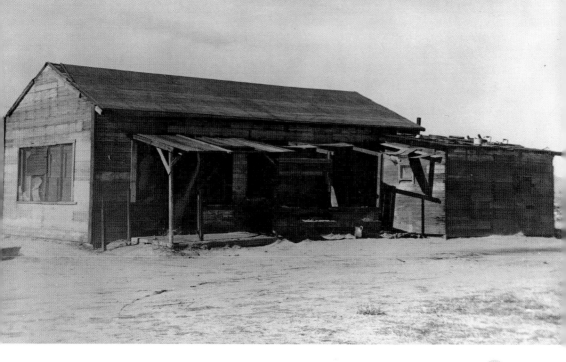

In 1926, successful Los Angeles businessman Lela Murray sold his business and moved with his wife, Nolie B., a devoted nurse, to the Bell Mountain area of Apple Valley. The extraordinary black couple bought a 40-acre property for $100 and opened a health ranch for children of all races that operated successfully for many years. The Murrays were dedicated churchgoing people who treated people of all colors the same, despite living in a Sundowner area. (Past image, courtesy of Apple Valley Legacy Museum.)

Eventually, the couple opened the Murray Overall Wearing Dude Ranch, the only black-owned and black-welcomed dude ranch in the country. Featured in Candacy Taylor's book *Overground Railroad*, the ranch was popular with Hollywood movie stars and athletes like Joe Lewis and Herbert Jefferies. The ranch was the backdrop for many movie shoots and open to everyone. The Murray Overall Wearing Dude Ranch was featured on *Ebony* and *Life* magazine covers, which shot its popularity through the roof. (Past image, courtesy of Apple Valley Legacy Museum.)

Superstar singer Pearl Bailey bought the Murray ranch and continued its lasting success by putting her personal touch on the property. Bailey, who wrote about her Apple Valley experience in *The Raw Pearl*, lived on the property and hosted a variety of well-known guests during her era. Bailey was known as an outstanding cook. Though she did not live in the Murrays' former home, Bailey built her own house that stands today in the Bell Mountain area west of Waleew Road. (Past image, courtesy of Apple Valley Legacy Museum.)

NEW BEGINNINGS

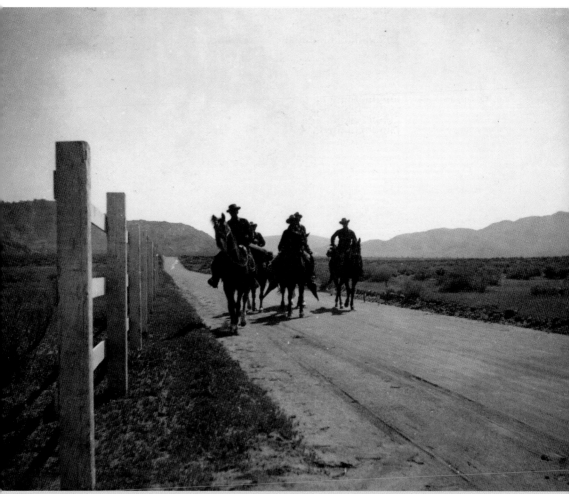

Members of the Apple Valley Sheriff's Posse ride their horses along an Apple Valley trail during the 1950s. The Apple Valley Sheriff's Posse was an official outlet of the San Bernardino County Sheriff's Office and operated with formal officers. This volunteer group of men served as law enforcement and assisted in fire control and search and rescue missions. (Courtesy of Town of Apple Valley.)

The real estate machine that became Apple Valley Ranchos began as Tripp Realty. This "Tract Office," located at the southeast corner of Highway 18, was a well-used Indian, pioneer, and ranchers' travel route across the Mojave Desert. At the inception of the Bass/Westlund enterprise, neither man possessed the broker's license necessary to complete the deal. Bennett Tripp, a Long Beach real estate broker, opened the first real estate agency in the area with the partner's encouragement. (Past image, courtesy of Town of Apple Valley.)

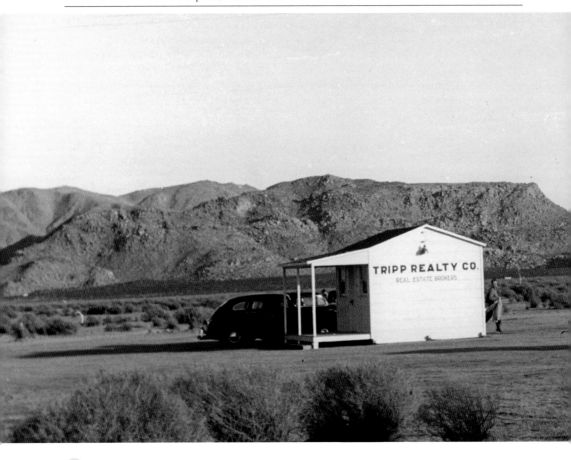

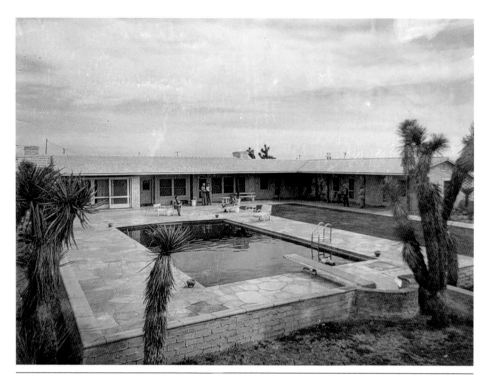

Known now as "the Pink House," this sprawling home on Navajo Road just north of Highway 18 served as the first Apple Valley Ranchos office. According to Apple Valley Legacy Museum historian Marcella L. Taylor, Bass and Westlund sold their first town lot on February 22, 1946. This parcel was in Apple Valley Ranchos Unit 1, which consisted of a tier of 25 lots on the east side of Navajo and another 100 lots on the west side. (Past image, courtesy of Apple Valley Legacy Museum.)

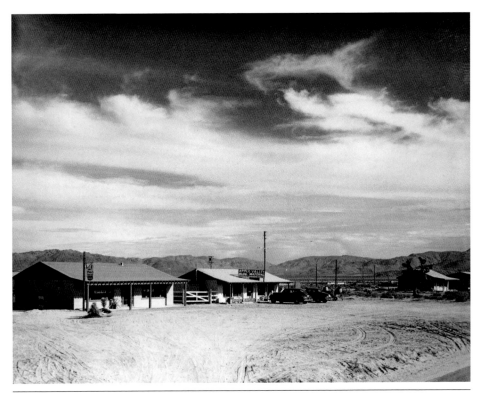

In 1948, Apple Valley Building Materials (right) was the first commercial establishment to take up residence in what was then the future town of Apple Valley. Owned by Paul S. Johnson, Apple Valley Building Materials supplied the developers who helped create Apple Valley's "Better Way of Life." Apple Valley Building Materials was followed by the Double R Tradin' Post, erected in 1947, a general store–type location where early settlers could buy necessities. (Past image, courtesy of Huntington Library.)

One of the many features that made Apple Valley popular was its horse-friendly Western lifestyle. All early buildings were equipped with hitching posts, and all homesites were planned around a generous system of horse trails still in service today. Horse travel was Apple Valley's preferred mode of early transportation. The Double R Tradin' Post was a popular hangout for horses and their men. A vintage newspaper article reported that *King Kong*'s Fay Raye owned the store at one time. (Past image, courtesy of Town of Apple Valley.)

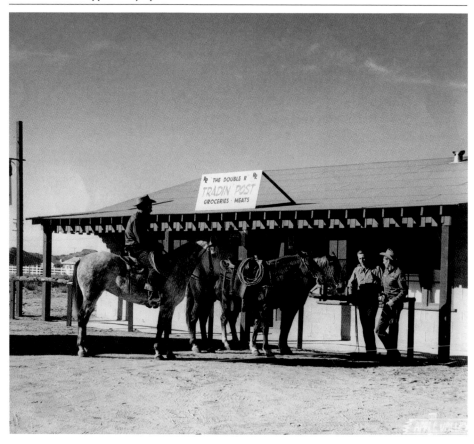

The Double R Tradin' Post continued to be a vital grocery stop for the Apple Valley Village neighborhood for decades, trading owners and eventually company names. In 1952, Apple Valley residents could buy beef short ribs for 29¢ a pound, T-bone roasts for 9¢ a pound, and grapes for 10¢ a pound at the Double R Tradin' Post. (Past image, courtesy of Apple Valley Legacy Museum.)

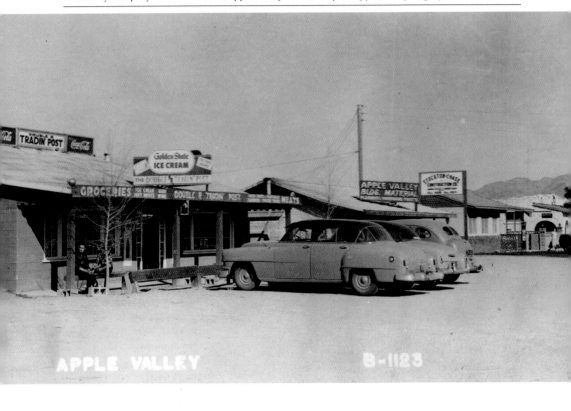

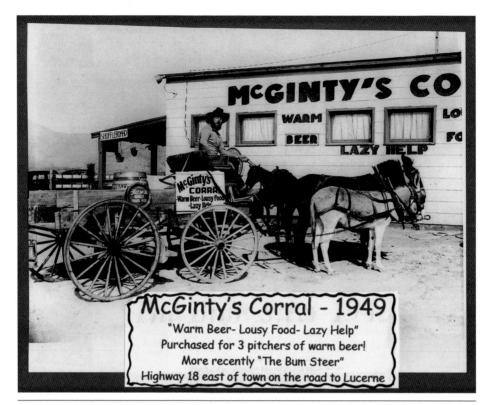

McGinty's Corral - 1949
"Warm Beer- Lousy Food- Lazy Help"
Purchased for 3 pitchers of warm beer!
More recently "The Bum Steer"
Highway 18 east of town on the road to Lucerne

Opened in 1948, McGinty's Corral is an important part of Apple Valley's history. This popular bar and watering hole was known for "warm beer, lousy food, and lazy help." Weary cowboys and construction workers wore a path to the east end of Highway 18, hitched their horses and parked their cars, and then enjoyed this early Apple Valley establishment. According to a 1949 *Apple Valley News* business roundup, the Apple Valley Women's Club enjoyed its installation dinner at McGinty's Corral. (Past image, courtesy of Apple Valley Legacy Museum.)

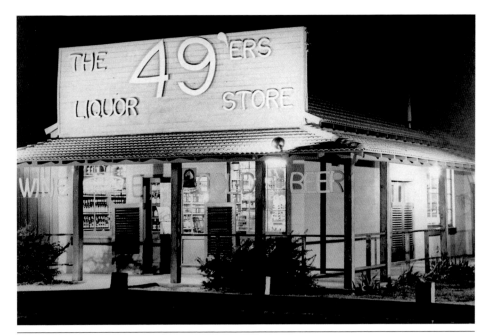

Another early necessity, the 49'ers Liquor Store sat in the village. Owner Harold Bertoletti was a popular, outspoken character who bought a piece of property and "built it brick by brick." Bertoletti said that the earliest business community was construction-related, and everyone held two professional positions. Along with his liquor store, Bertoletti was the Bennington & Smith Construction Carpenter superintendent. Bertoletti said Bass forced all his salesmen to buy land and erect buildings, but everyone needed to relax occasionally. (Past image, courtesy of Town of Apple Valley.)

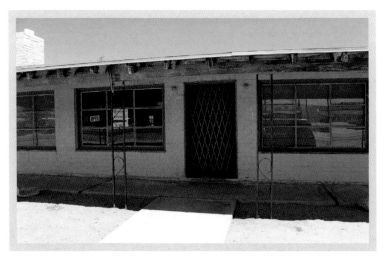

Ralph and Linda Edwards, enchanted by the ranchos dream and forced by contract to build within one year of relocating, moved their family from Bellflower to Apple Valley in 1947. "The Apple Valley Development Company talked Ralph into sharing a furniture, upholstery and drapery store to service anticipated thousands who would choose Apple Valley Ranchos as their home," according to an Edwards family history book. Ralph and his brother Dick built Frontier Furniture, which had the family's living quarters attached. (Past image, courtesy of Polson family.)

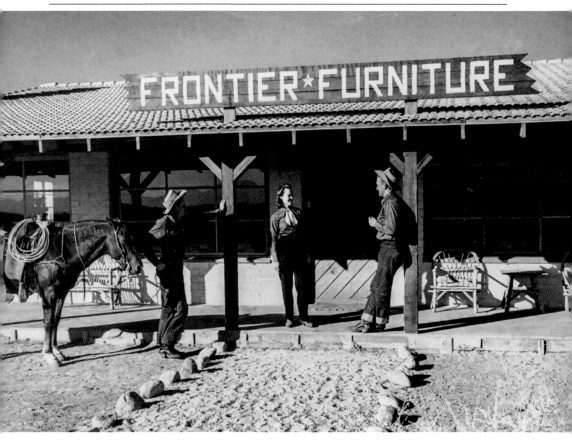

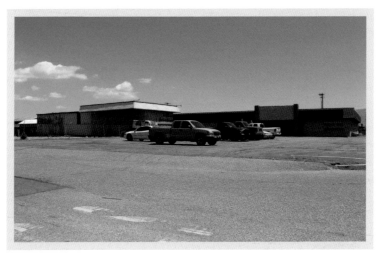

G.R. Torkelson opened Apple Valley Lumber Company in competition with Apple Valley Building Materials. Apple Valley Lumber was the longest-running, and, at the time of this photograph, the two competing companies operated within a few blocks from one another. A third store, Apple Valley Hardware, opened in 1955. Apple Valley Lumber moved to the northeast corner of Quinnault Road and North Outer Highway 18 and is now demolished. That property was recently renovated as Townsend. (Past image, courtesy of Town of Apple Valley.)

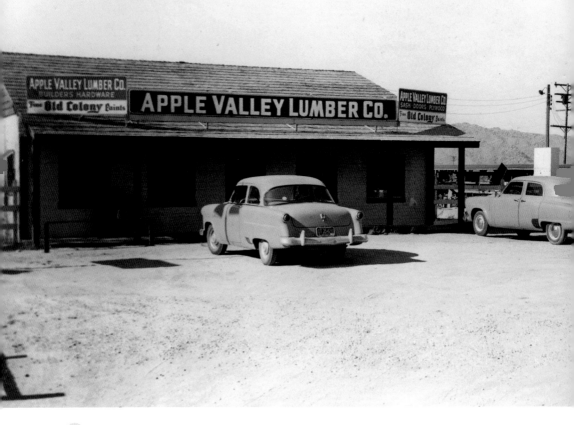

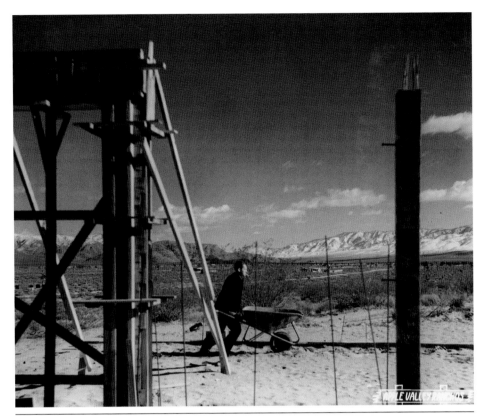

Stan Polson pushes a wheelbarrow across the soft sand at the southwest corner of Central Road and Highway 18 to frame what will become the Apple Valley Ranchos Livery Stable. Polson, who is smoking a cigarette and pushing into the wind, was later utilized by the Bass empire to become the face of the Apple Valley Ranchos cowboy. Polson operated the livery stable with partner Bill Beardsley. The livery stable boarded horses, led trail rides, and much more. (Past image, courtesy of Town of Apple Valley.)

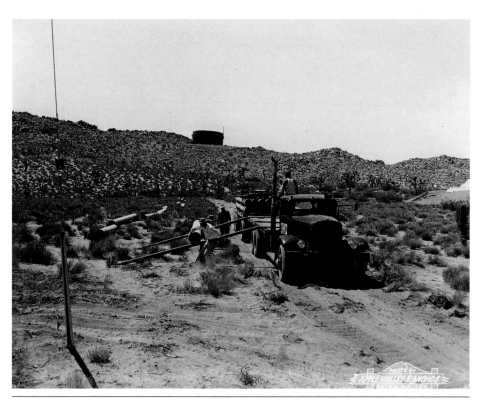

Before Bass and Westlund could build their high-end, Western-style desert resort for Hollywood celebrities and wealthy business owners, the pair had the huge task of piping water throughout the area. Carpenter Harold Bertoletti said that pipe was unavailable in early Apple Valley because production was stifled during World War II. This water tank was installed on a natural outcropping of beautiful rock formations above what would soon become the Apple Valley Inn. Before the tank's installation, that natural, rugged, and statuesque location had not been accessed regularly since the days of Indian tribes who inhabited the area. (Past image, courtesy of Town of Apple Valley.)

These men lay pipe along what appears to be South Outer Highway 18. While the man on the far right labors to force a drill into the hard desert earth, the man to his left climbs onboard the pipe; a third man sits atop a drill; and a fourth man (far left) appears to be reading a book. Ranchos's original plans say about 300,000 feet of pipe, from 2 inches to 12 inches in diameter, were installed to serve every homesite. (Past image, courtesy of Town of Apple Valley.)

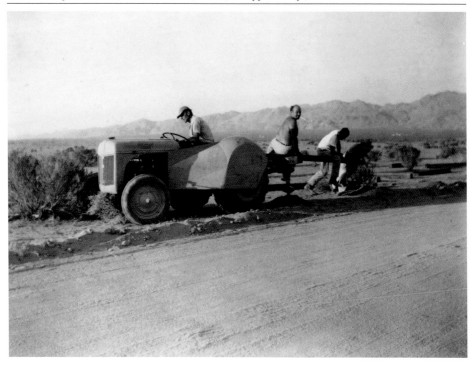

The first bar/church available to early Apple Valley residents was the Branding Iron. At the time, a common joke circulated that a patron could get drunk on Saturday, wake up, and go to church on Sunday. The Branding Iron served as a community dance hall and hosted large events until the Apple Valley Community Center was built. Now demolished, the Branding Iron sat at the southwest corner of Highway 18 and Central Avenue. Only the original oven remains. (Past image, courtesy of Town of Apple Valley.)

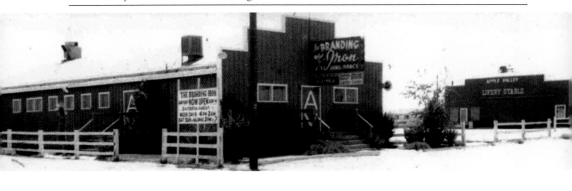

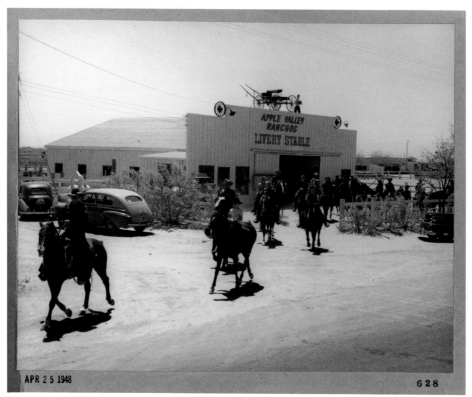

APR 25 1948

628

The Apple Valley Ranchos Livery Stable, co-operated by Stan Polson and Bill Beardsley, was another integral location. Bass and Westlund's master plan mandated all the necessary Western facilities needed for the upkeep of this popular lifestyle. Founding families memorialized this now-demolished site by donating photographs of its heyday. Here, a group of local riders heads out on a trail ride, a regular Apple Valley pastime. The stable was located just a few yards west of the Branding Iron. (Past image, courtesy of Town of Apple Valley.)

Leo Chase, whose daughter Diane Irwin still lives in Apple Valley, built the El Pueblo Shopping Center, Apple Valley's first strip mall. Located east of Navajo Road on North Outer Highway 18, the El Pueblo held nine shops. In 1948, shops included the Do-Nut Bar, the Lazy Two Drugs, Children's Round-Up, Victor Valley Insurance Agency, Larriato Café, Stockton-Chase, Oasis Malt Shop, Joshua Barber Shop, and Crawford's Corral, according to a 1948 *Apple Valley News* business roundup article. (Past image, courtesy of Town of Apple Valley.)

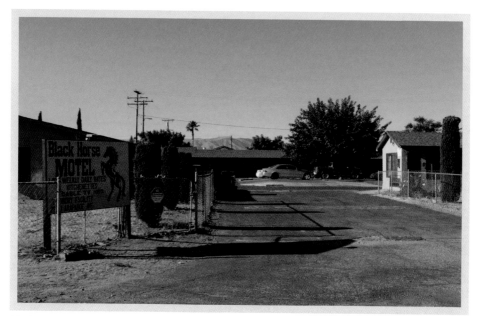

Black Horse Motel owners Frances and Frank Cornia found their home on a lark after choosing a random picnic lunch spot before meeting a Tripp Real Estate agent. The Cornias then asked the salesman to find the perfect spot for a motel, and the agent took the family to the spot where they had just finished lunch. The Black Horse is named after Frank Cornia's beloved horse Raven and is in business as originally named on Arapahoe Avenue and Quinnault Road. (Past image, courtesy of Town of Apple Valley.)

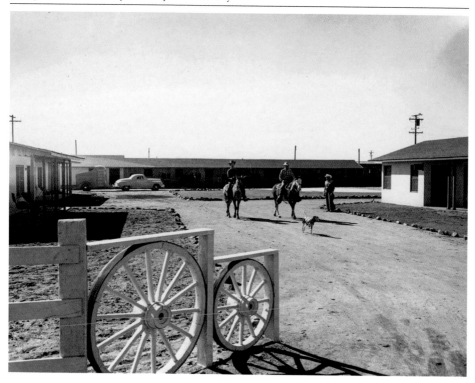

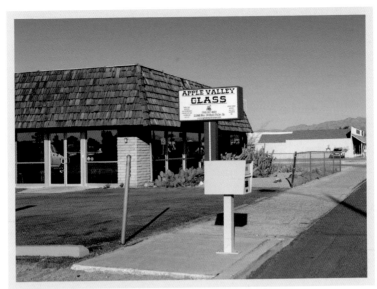

During the 1950s, the Al and Esky Villager Restaurant, known as "the Villager," sat in the original village and earned its way into history by word-of-mouth reputation. Many founding pioneers talked about its food, service, and atmosphere in memoirs. Today's Apple Valley resident would not recognize the Villager. Today, the Villager is home to Apple Valley Glass and is located on North Outer Highway 18, several lots west of Pawnee Road. (Past image, courtesy of Town of Apple Valley.)

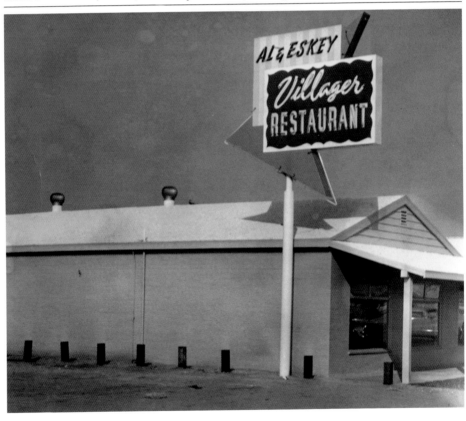

NEW BEGINNINGS

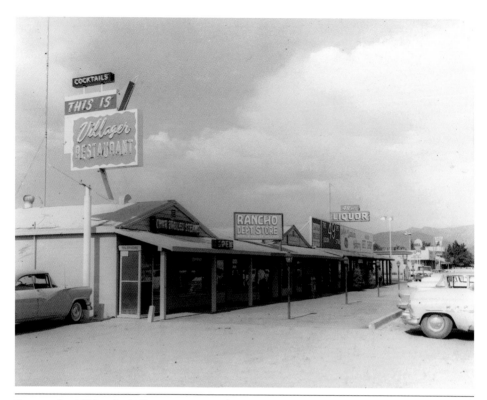

During the 1950s, the Villager was part of a small strip mall. Rancho Department Store, now an empty lot, still shows its scarred foundation. Beyond that location, the 49'ers Liquor Store, Apple Valley Danish Bakery, and Apple Valley Gift Shop did good business. George Leonard Garage sits at the corner of North Outer Highway 18 and Pawnee Road. Harold Bertolleti bought his 100-foot lot for $2,000 and built the 49'ers store. He later expanded his store to a triplex. (Past image, courtesy of Town of Apple Valley.)

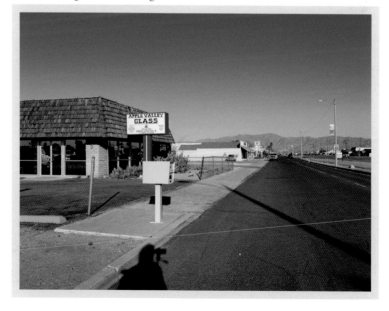

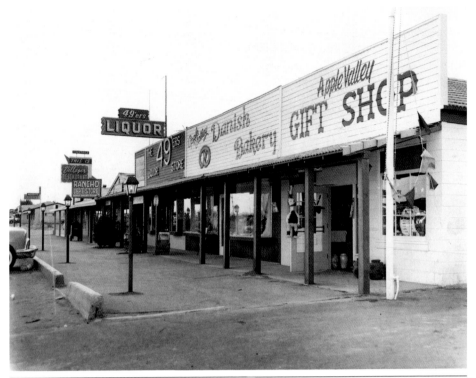

A view of the same stores, looking from the opposite direction, gives a clear view of Apple Valley Gift Shop, Apple Valley Danish Bakery, the 49'ers Liquor Store, Rancho Department Store, and of course, the Villager. Today's visitor to that North Outer Highway 18 location, set just west of Pawnee Road, would be stunned that the building housing the Meal Prep Company, Quality Used Furniture, and the Maison Garrison Boutique was such an old historic location. Renovations made this building unrecognizable through time. (Past image, courtesy of Town of Apple Valley.)

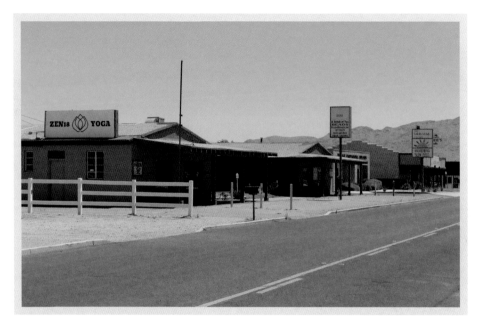

This oblique view shows the El Pueblo Shops' corner establishment, the Oasis Malt Shop, which sits at the westernmost boundary of this early village strip mall area. Fire ultimately claimed the easternmost café and its western neighbor, but the El Pueblo Shops still stand, closely resembling their original form. Today, the Village Professional Building sits on the lot of this former unknown store and café. Frogee's Cocktail Lounge appears to sit on the empty lot west of the café. (Past image, courtesy of Town of Apple Valley.)

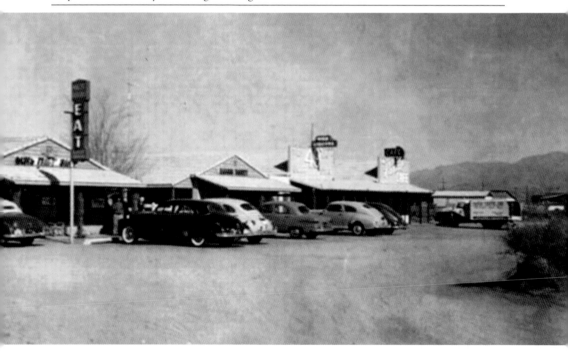

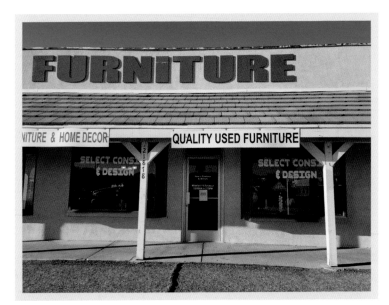

In a 1950s *Desert Valley News-Herald* article, Apple Valley Danish Bakery owners Leo and Linnie Anderson report great success. The Andersons said they chose the desert as their home in 1949 and began business in 1953. The Andersons believed in friendliness, courtesy, and good service and said 7,500 visitors enjoy the bakery each month. Early resident, postmistress, and first librarian Edna Hollenbeck said she loved walking from the post office to the bakery every day for a snack. (Past image, courtesy of Town of Apple Valley.)

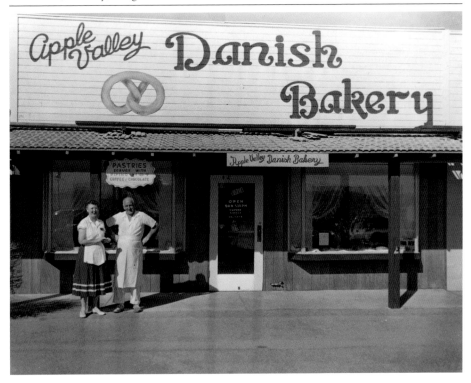

MARKETING ON STEROIDS

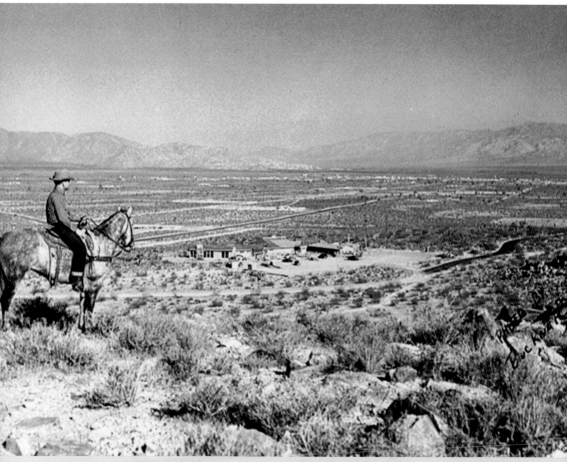

Stan Polson, who operated the Apple Valley Ranchos Livery Stable, sits atop his horse on the rocky outcropping a few hundred feet north of a huge water tank surveying the construction of the Apple Valley Inn. Opened in 1948, the Apple Valley Inn was the Bass/Westlund showpiece and was designed to draw wealthy businessmen and residential spectators as well as the Hollywood movie-making industry to the area. (Courtesy of Town of Apple Valley.)

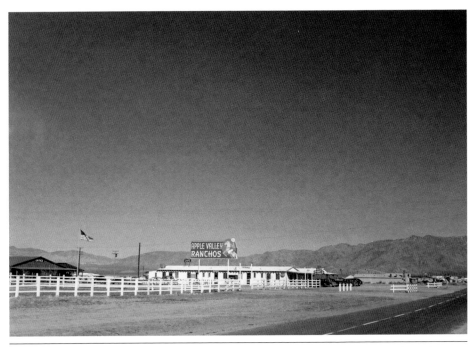

This aerial view of the sprawling Apple Valley Ranchos gives no indication that it is today's intersection of Navajo Road and Highway 18. The Ranchos building was eventually demolished and replaced with a Rite Aid. Today, Navajo Road is paved directly through the Ranchos riding arena, and Del Taco is on the corner of North Outer Highway 18. The Pink House is barely visible at left, and the Black Horse Motel is located beyond the telephone pole in the background. (Past image, courtesy of Huntington Library.)

MARKETING ON STEROIDS

Newton Bass was not a humble man. His shows of wealth and strength as a marketer compelled entire communities to show up at his events. It was mandatory for employees. This event took place on the west side of Apple Valley. The giant lighted sign sat in what is now the middle of Highway 18, near the present-day Dale Evans Parkway. Bass required his salesmen to be available for service and work 24 hours a day, seven days a week. (Past image, courtesy of Apple Valley Legacy Museum.)

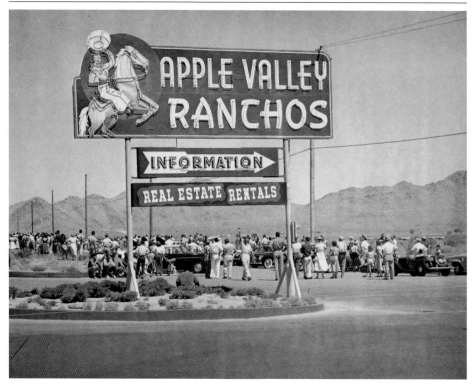

This location, at the corner of Highway 18 and Dale Evans Parkway, was Apple Valley Ranchos' final sales office location. This modern building housed Bass's sales force, conference facilities, and a giant mural map across an entire wall that displayed what beautiful Apple Valley had for sale. Today, Agio Realty owns this building. Its interior is upgraded, modern, and barely shows this building's history. But the original floor-to-ceiling Apple Valley mural map still adorns the wall in its original location. (Past image, courtesy of Huntington Library.)

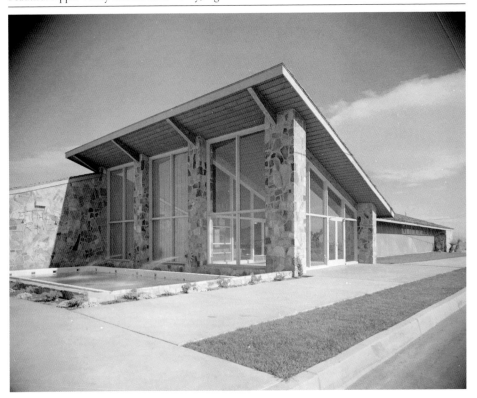

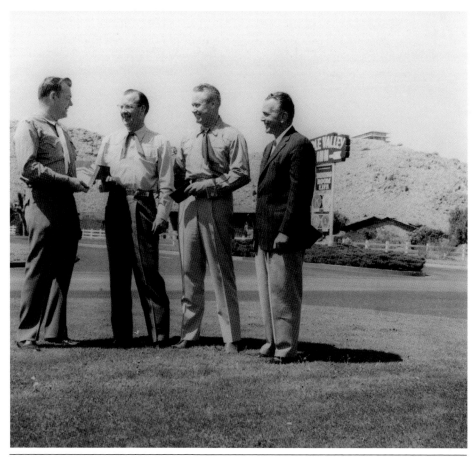

Salesmen at Apple Valley Ranchos were handsomely rewarded for their on-the-spot service. In this photograph, it appears that Bud Westlund (second from left) is awarding another agent for excellent sales. Ranchos salesmen were required to wear red and blue scarves, which each held a sales meaning, that they wore as part of their sales uniform. Today, this location is at the northeast corner of Dale Evans Parkway and North Outer Highway 18. (Past image, courtesy of Town of Apple Valley.)

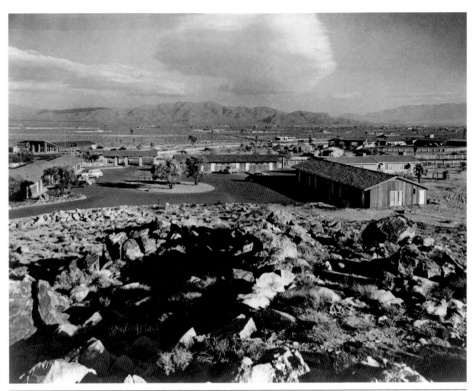

The Apple Valley Inn, located at the southwest corner of Highway 18 and Dale Evans Parkway, opened in 1948. The inn's buildings and landscape changed as it grew and underwent renovations. On the far left, Apple Valley Ranchos and its dramatic slanted roof can be seen. The Apple Valley Inn had several dining and banquet rooms, a trendy Hawaiian-style bar, and walls covered in murals depicting the Western lifestyle. The Apple Valley Inn was home to KVAR radio. (Past image, courtesy of Huntington Library.)

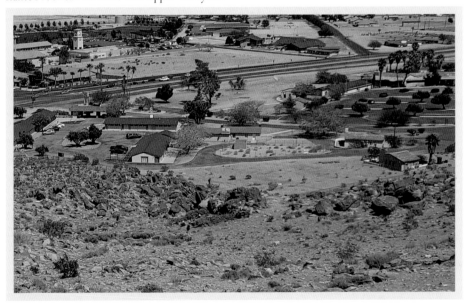

MARKETING ON STEROIDS

Some celebrities visited the Apple Valley Inn so often, that cabins were named in their honor. At left sits the Bob Hope cabin, which is now home to the Apple Valley Legacy Museum. The foreground cabin is named after Marilyn Monroe. Though some renovations were made, much of the inn's buildings use the original structural accoutrements. Visitors to the Apple Valley Legacy Museum can see the original fireplace, patio, and living area Bob Hope used when he stayed at the inn. (Past image, courtesy of Town of Apple Valley.)

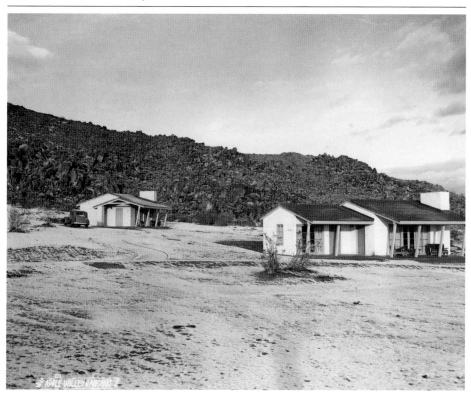

Roy Rogers leased the Apple Valley Inn during 1965 and took the Hollywood draw to new heights. Rogers and Dale Evans changed the name to the Roy Rogers Apple Valley Inn. They hosted countless outside steak fries and had a stable that offered horseback riding as well as hayrides. Roy Rogers's horse, Trigger, was often stabled at the inn. The inn's cooks were famous, and its service was well known. Dale Evans was known to spend hours at the inn's magnificent kitchen. (Past image, courtesy of Apple Valley Legacy Museum.)

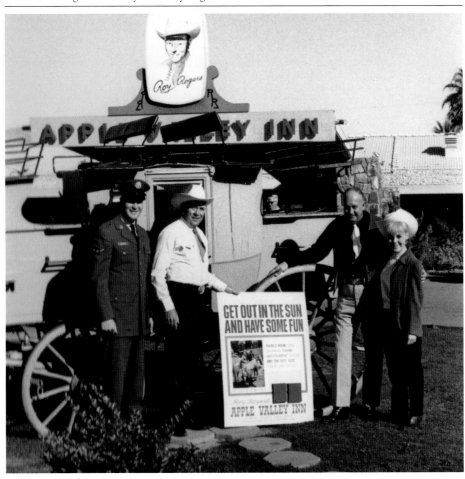

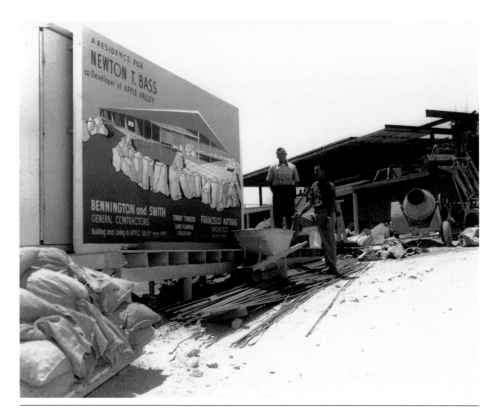

The Bass/Westlund duo built Apple Valley's famous Hilltop House to entertain and pursue wealthy investors. The sign in this photograph is misleading. The house was not Bass's personal residence but was technically built for Bass and Westlund to entertain. Bass and Westlund hired Mexican architect Francisco Artigas and local builders Bennington & Smith to create the house that still stands as the centerpiece conversation starter in Apple Valley. (Past image, courtesy of Town of Apple Valley.)

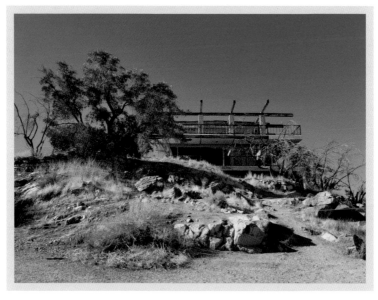

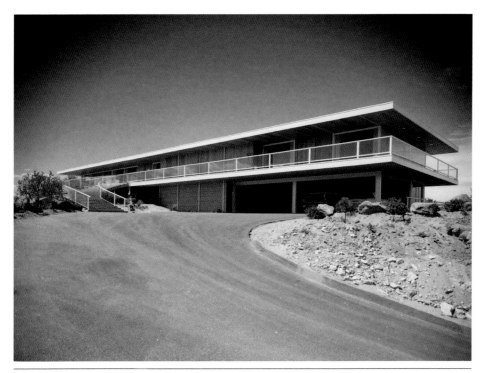

The Hilltop House was a steel-framed, 7,000-square-foot, two-level home that featured a pool that could be entered from the living room and exited from outside. The house is located directly above the Apple Valley Inn and offers 360-degree views. The Hilltop House burned down twice, changed hands several times, and is now owned by the Town of Apple Valley. An Apple Valley Legacy Trail preservation group now works with the town to restore the historic location. (Past image, courtesy of Huntington Library.)

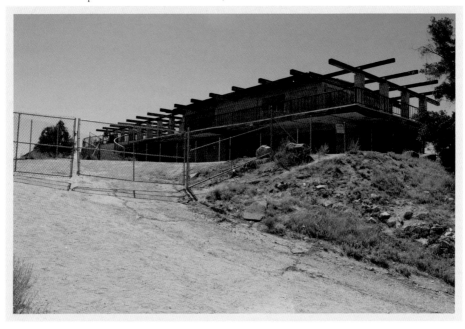

One of the Apple Valley Inn's trademark events was its Steak Fry, an outdoor barbecue of superior steak held at the steak fry grounds located first northwest of the inn and then, under the Roy Rogers reign, on the inn grounds. Attendees were treated to a barbecue steak dinner made with beef that Bass raised on his own farm located at the northeast end of Apple Valley. Modern-day steak fries are held by the Apple Valley Legacy Museum during the summer. (Past image, courtesy of Town of Apple Valley.)

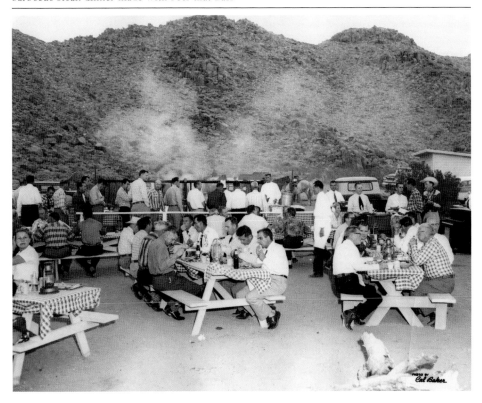

Across the street from the Apple Valley Inn and next door to Apple Valley Ranchos lies the Apple Valley Airport. Bonanza Air Lines and Western Airlines landed on the 2,750-feet-long airstrip, along with private and special planes. The airport was less than a mile from the resort, making relaxation in the desert a convenient reality. The original airport was located east of Agio Realty, near the corner of Dale Evans Parkway and North Outer Highway 18. (Past image, courtesy of Apple Valley Legacy Museum.)

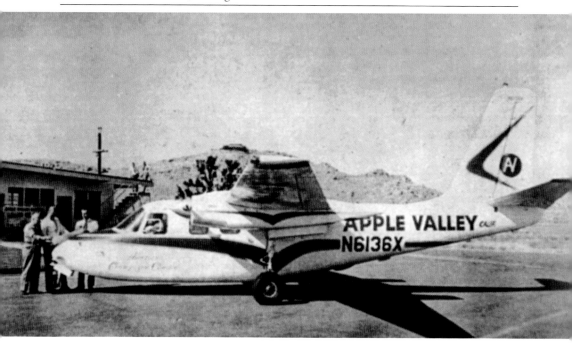

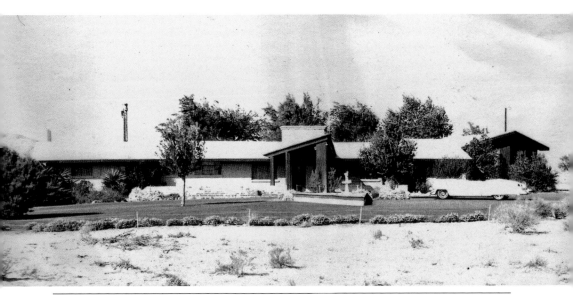

Bud Westlund and his wife, Dorothy, built this Highway 18, four-bedroom, two-bath house on a two-acre property. The couple added another wing and renovated extensively. In 1964, when Roy Rogers and Dale Evans leased the Apple Valley Inn, they also purchased this home. Roy Rogers and Dale Evans lived in this home until the 1980s. The Westlund/Rogers home is now part of several historical site tours. Directions are available at the Apple Valley Legacy Museum. (Past image, courtesy of Apple Valley Legacy Museum.)

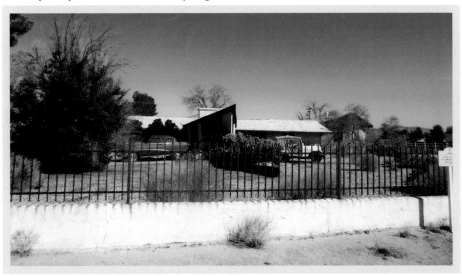

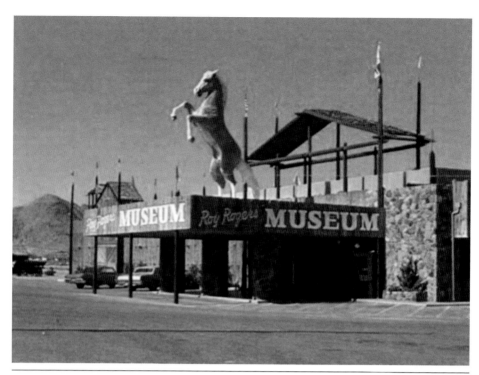

Roy Rogers and Dale Evans opened the Roy Rogers Museum in 1967, a few blocks east of their home. In 1994, the town renamed Highway 18 as Happy Trails Highway in their honor. The Roy Rogers Museum moved to Victorville in 1976, and then, following Roy Rogers's death in 1998 and Dale Evans's death in 2003, the museum moved to Branson, Missouri. The Roy Rogers legacy continues in Apple Valley through the Happy Trails Children's Foundation that operates in the area today. (Past image, courtesy of Mohahve Historical Society.)

BACK AT
THE RANCHO

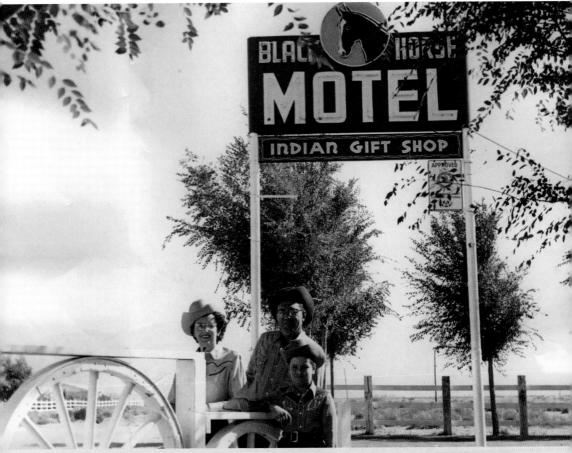

Frances and Frank Cornia stand with their son Danny in front of the Black Horse Motel. The Cornia family, which also included "Johnny," their daughter (not pictured), built in Apple Valley after a serendipitous picnic adventure. This unique, popular motel housed people and their horses throughout the early era and held an Indian Gift Shop that later allowed the couple to build the Buffalo Trading Post. Eventually, the stables were replaced by additional rooms. (Courtesy of Apple Valley Legacy Museum.)

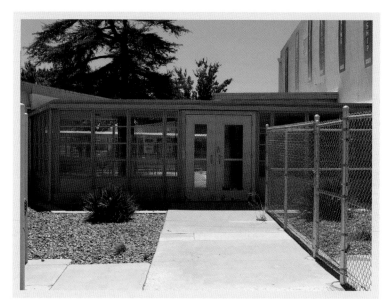

This school photograph captures the early days of Apple Valley School before it was renamed Yucca Loma School. Though this photograph does not depict it, the original building from the second Apple Valley School located at the southeast corner of Bear Valley and Deep Creek Roads was moved to this site when the third Apple Valley School was erected. Today, the Yucca Loma School is the cornerstone campus for the rest of the Apple Valley School District. It continues as an elementary school today. (Past image, courtesy of Town of Apple Valley.)

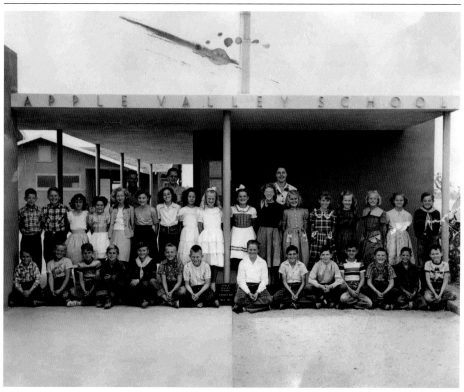

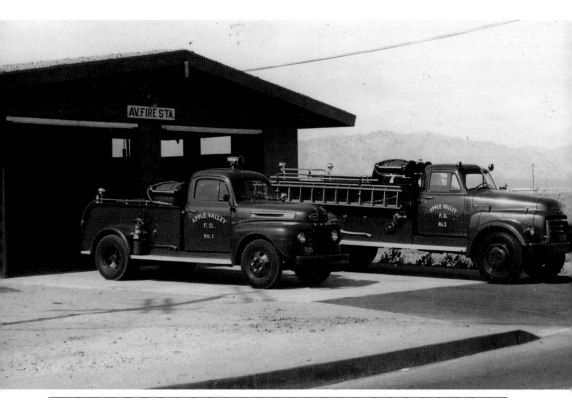

Pioneer Harold Bertolotti said forming a fire department was one of the first things early residents tackled. Early businessmen were concerned there was no way to stop an advancing fire if one started in the desert. The first item acquired for the newly formed department was a truck with a 500-gallon tank, a pump, and some hoses. This photograph shows Station No. 1 during its heyday and is located on the northwest corner of Wakita Boulevard and North Outer Highway 18. (Past image, courtesy of Town of Apple Valley.)

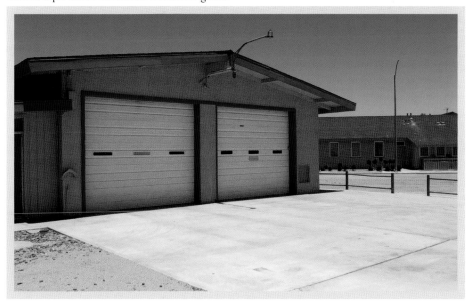

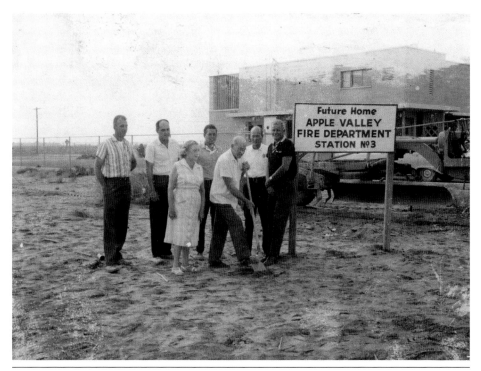

As the population exploded, so too did the need for additional infrastructure. This groundbreaking event is for Fire Station No. 3, located in the Knolls neighborhood. It sits east of the Newton Building. Today, the Apple Valley Fire Protection District covers 206 square miles and responded to more than 13,209 incidents in 2020, according to its site. It investigated more than 208 fires. Today's department employs 51 full-time and three part-time personnel members. (Past image, courtesy of Town of Apple Valley.)

Converted from a service station to a small eatery named the Waffle House, this tiny brick building was considered a favorite to residents from Apple and Lucerne Valley. Owned by Linda Forrester, the Waffle House's reputation was stellar. John Weldy, the owner of the market next door, said he loved Forrester's fried spaghetti. The Waffle House, located at the northeast corner of Bear Valley Road and Central Avenue, marked dead center for a small commerce area known as Cotner's Corner. (Past image, courtesy of Town of Apple Valley.)

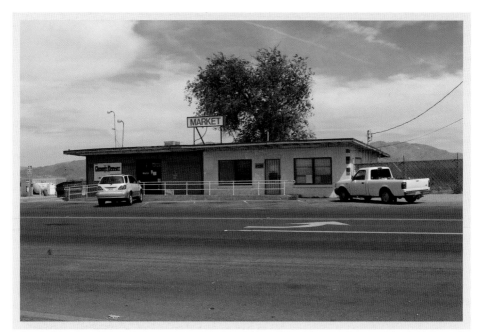

Located immediately north of the Waffle House, the historic Archer's South Apple Valley Market was razed in 2020, destroying the last remnants of Cotner's Corner. In the mid-1950s, John Weldy purchased the market and ran it as Weldy's from 1957 to 1962. June and Tom Archer then purchased the store, according to a 2005 *Daily Press* article. A barbershop also operated within the Archer's building. Patrons frequented the two stores until they were destroyed. (Past image, courtesy of Town of Apple Valley.)

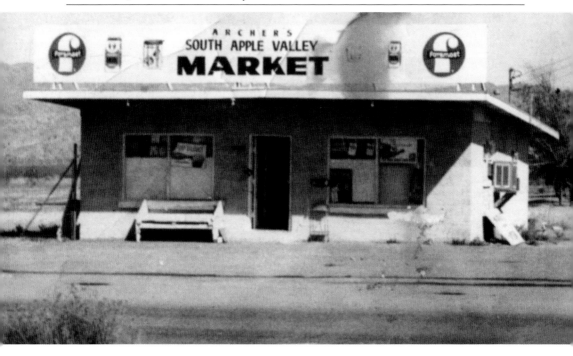

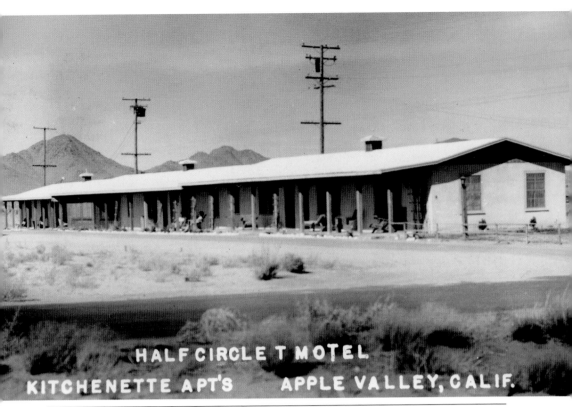

HALF CIRCLE T MOTEL
KITCHENETTE APT'S APPLE VALLEY, CALIF.

In its heyday, the Half Circle T Motel was a popular place for relaxation and entertainment. Located at the northwest corner of Flathead Road and North Outer Highway 18, this motel's entertainment facility hosted singers, comedians, and musicians, according to an *Apple Valley News* article. Today, this location is an empty field, though some seemingly random bushes that once lined one wing of the motel's room hide part of the original concrete foundation still planted in the ground nearby. (Both images, courtesy of the author.)

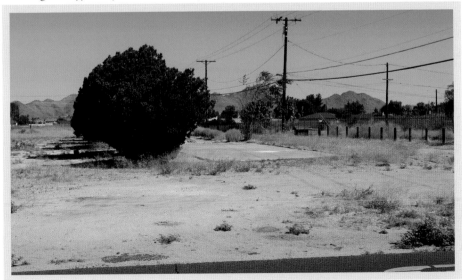

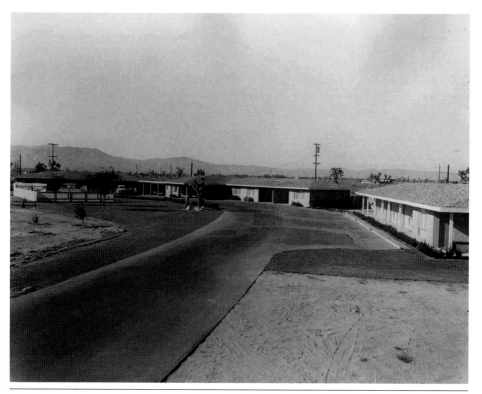

The Ocotillo Motel, located on the southwest corner of Kiowa Road and South Outer Highway 18, was close to the Apple Valley Inn; they were separated only by a field. The Ocotillo was sold and renamed Sandy's Apple Valley Resort Lodge. Today, it is the Apple Valley Motel and looks nearly identical to its predecessors. Its location was advantageous for customers unable to afford a room at the upscale inn. Today, the Apple Valley Motel offers air-conditioned rooms for rent by the week. (Past image, courtesy of Town of Apple Valley/Apple Valley Legacy Museum.)

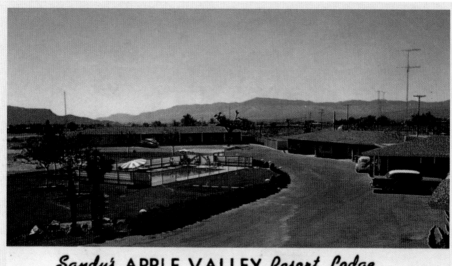

Sandy's APPLE VALLEY Resort Lodge

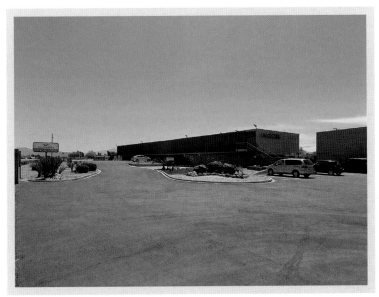

The Oja Motel was a stylish, modern weekend stopover spot located on the southwest corner of Piute Road and South Outer Highway 18. The Oja, later the Oasis Motel, has transformed many times, taking on a variety of names. This location was recently purchased, fully renovated, and newly reopened as the Apple Valley Lodge and Motel. The new owner's makeover celebrates its classic retro and architecturally distinct exterior as well as its close location to the Apple Valley Country Club. (Past image, courtesy of Town of Apple Valley.)

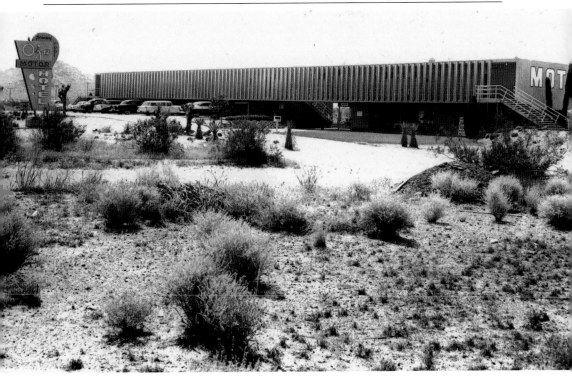

During the 1950s, manufacturers moved the Terri Lee Doll company to Apple Valley, creating hundreds of jobs. Along with its manufacturing buildings on Central Avenue, the Terri Lee Doll company had a hospital/ranch near the northeast corner of Bear Valley Road and Hesperia Road and an art building for "piece work," like painting eyes on the dolls. This photograph, taken at the Dale Evans Parkway location, shows the building's pool, which was filled in when the structure was repurposed in 1990 as the library. (Past image, courtesy of Apple Valley Legacy Museum.)

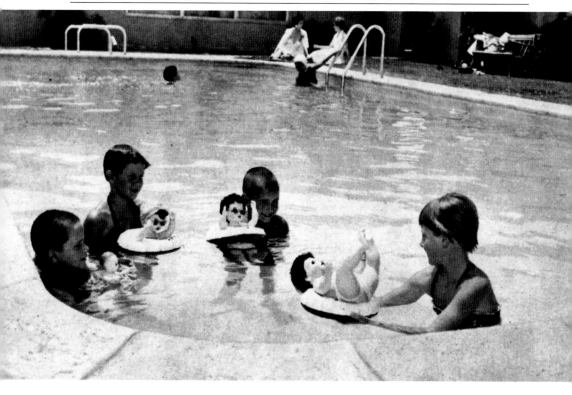

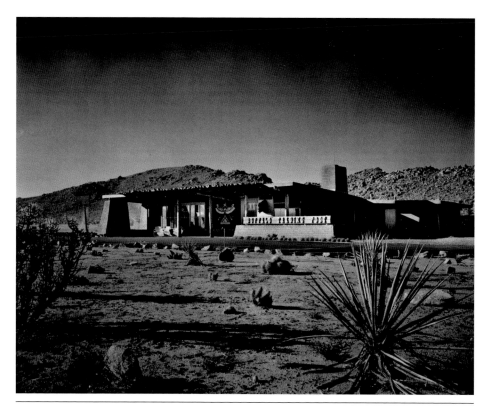

Frank and Francis Cornia offered their Black Horse Motel for sale on Friday and sold it on Monday, according to a news article. Local architect Douglas McFarland witnessed that miracle sale and started designing the Buffalo Trading Post, the Cornias' next generations-long Apple Valley business. Known for fine Indian jewelry, this store is located at the southeast corner of Rancherias Road and South Outer Highway 18. The original structure and painted buffalo still showcase the area's unique Western lifestyle. (Past image, courtesy of Apple Valley Legacy Museum.)

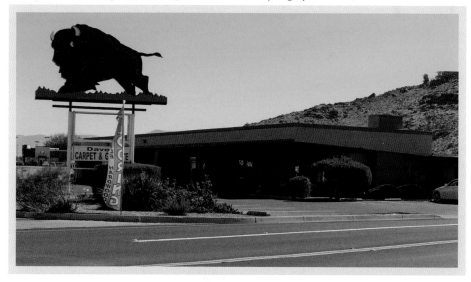

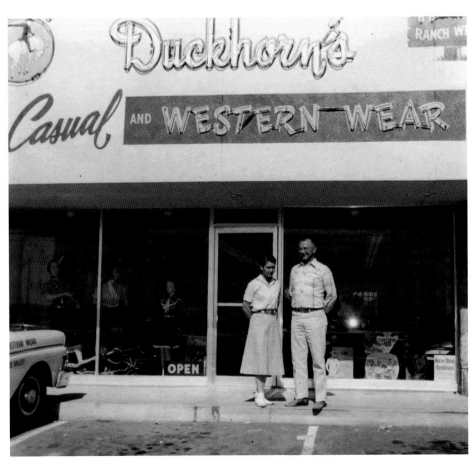

Along with many other successful clothing retailers, Duckhorn's Casual and Western Wear served High Desert residents for many years. Duckhorn's was located on Apple Valley's west border in an area now known for its proximity to the massive St. Mary Medical Center. The Duckhorn's building, located on North Outer Highway 18 just west of St. Mary Medical Center, was transformed into a doctor's office. When Duckhorn's was in business, their neighborhood was referred to as Desert Knolls, or "the Knolls." (Past image, courtesy of Town of Apple Valley.)

Along the same strip mall that today houses several medical facilities and a massage spa was, in the 1960s, a retail center that held Granger's Corral, which was a variety store; Jaqueline Speare School of the Dance; Duckhorn's; and Desert Knolls Pharmacy, among others. The Desert Knolls area was, at the time, known as the "new" part of town. Today's medical facility is located west of St. Mary Medical Center on North Outer Highway 18. (Past image, courtesy of Town of Apple Valley.)

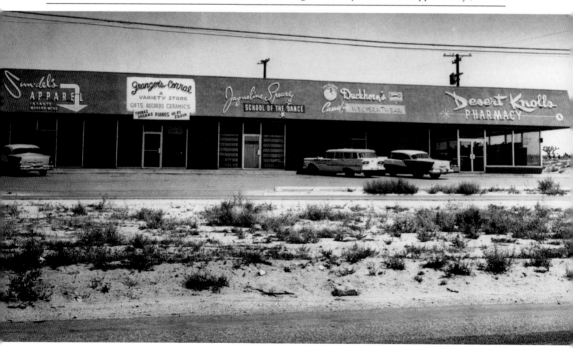

The Apple Valley Country Club was another Ranchos staple used to entertain and seduce wealthy potential residents to the area. This photograph shows the early days of the country club and one of its vehicles. The original clubhouse is located on the middle-left border of the photograph. The Apple Valley Country Club is located on Rancherias Road, close to South Outer Highway 18. Professional golfer Lloyd Mangrum, the winner of multiple Los Angeles Open titles, was the club pro. (Past image, courtesy of Town of Apple Valley.)

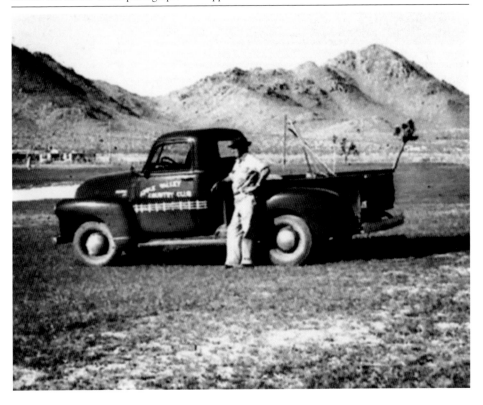

BACK AT THE RANCHO

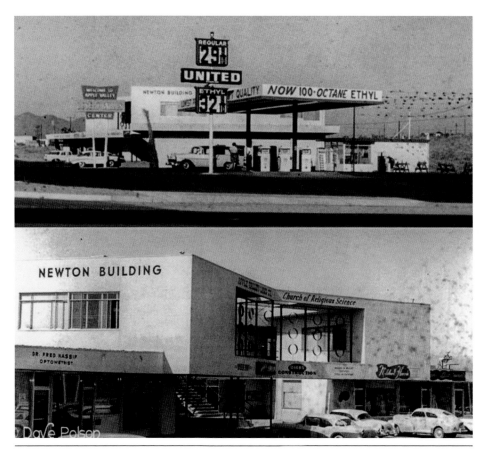

Far from the Western lifestyle theme, the Newton Building housed offices and a church as well as a liquor store. Travelers could fuel up on gas directly west of the Newton Building. Named the Apple Valley Desert Knolls Center, today's building remains occupied with businesses. The gas station is now part of Apple Valley Road and a 7-11 convenience store. This complex is located at the southeast corner of Highway 18 and Apple Valley Road. (Past image, courtesy of Town of Apple Valley.)

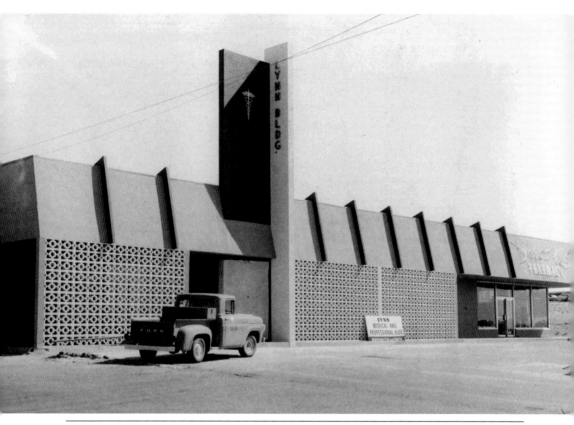

Located on the northwest corner of Kasota Road and North Outer Highway 18, the Lynn Building continues to stand, appearing completely different than its original design. Undergoing a series of remodels, the entrance shown above appears to be the Granger Corral's front door. There is no sign of St. Mary Medical Center in the original photograph, but the hospital was in its infancy during this time and located east of the original Lynn Building. (Past image, courtesy of Town of Apple Valley.)

Hilltop House builder Bennington & Smith was the well-known and coveted building contractor who erected the iconic Real Estate Center located at the southwest corner of Kasota Road and South Outer Highway 18. The building was owned by the Bass/Westlund team and advertised, "Buy or rent with confidence from Apple Valley's original real estate broker and founder." Despite a gallant effort to save this building, it was demolished in 2019 and replaced with a Starbucks. (Past image, courtesy of Town of Apple Valley.)

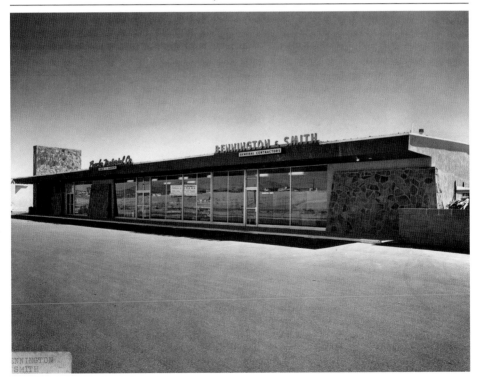

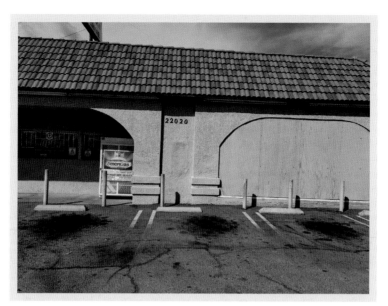

This undated photograph shows Lucky's Little Italy owner Salvatore "Lucky" Testa, who was so popular in the community that he was able to expand his local establishment. Located on the north side of Bear Valley Road, east of Central Avenue, Lucky's Little Italy was never the same after Testa was shot in the head at another restaurant when he was 45 years old. Today's building houses a liquor store and shows many of the same original architectural designs. (Past image, courtesy of Town of Apple Valley.)

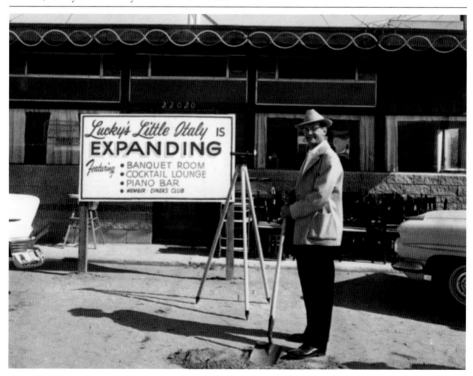

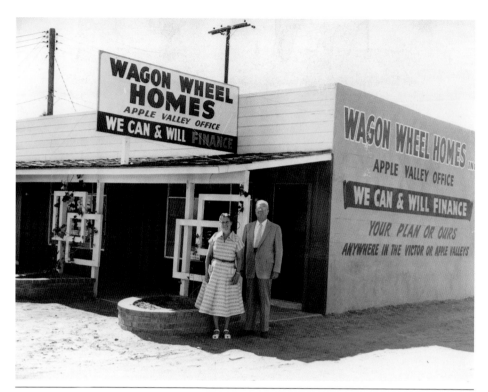

Wagon Wheel Homes' Apple Valley office was located east of Central Avenue on the north side of Bear Valley Road. Wagon Wheel Homes was owned by Harry Stanford of Hesperia and was the home office for the Rocking Horse tract. These tract homes were the first of their kind in Apple Valley and brought precious new population to the community. Rocking Horse houses were distinct in their design and architecture and built by M. Penn Phillips. (Past image, courtesy of Town of Apple Valley.)

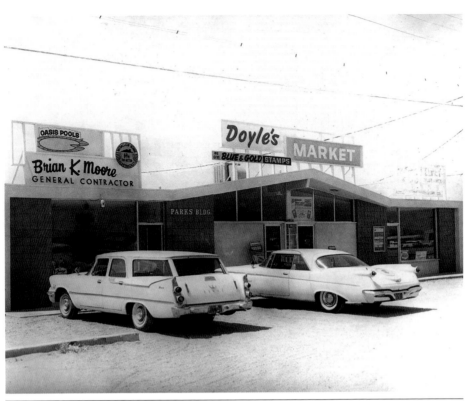

The Parks Building, now home to the Loyal Order of the Moose Lodge No. 1819, Apple Valley's family fraternity, is located at the southwest corner of South Outer Highway 18 and Del Mar. But it was first Doyle's Market. This vintage 1960s photograph showcases Blue and Gold Chip Stamps, given away at grocery stores and redeemable for other household items. Brian K. Moore, General Contractor, and Oasis Pools occupied the attached building. (Past image, courtesy of Town of Apple Valley.)

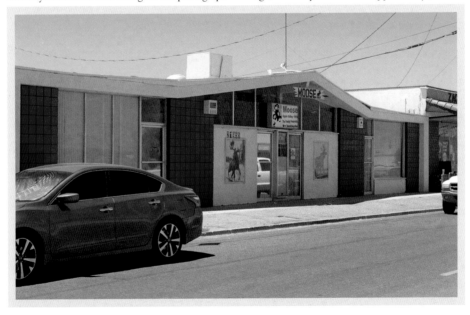

Joshua Drugs stayed in business for decades at the southwest corner of Pawnee Road and South Outer Highway 18. This building served Apple Valley residents under different pharmacy company names. Eventually, this building was transformed into Mollie's Country Kitchen, one of Apple Valley's current and most popular local family restaurants. Mollie's is just a few blocks away from Mama Carpino's, another Apple Valley staple restaurant. Many other longtime businesses also continue to serve residents. (Past image, courtesy of Town of Apple Valley.)

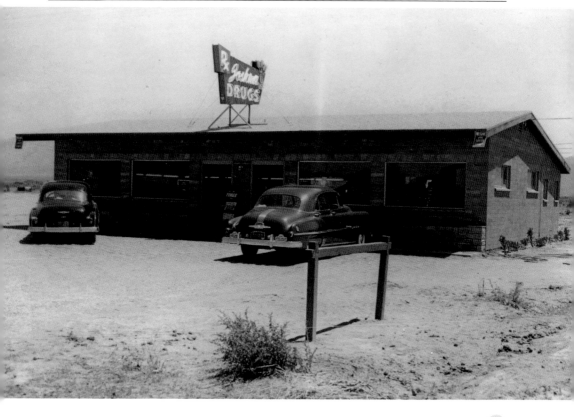

Like the Black Horse Motel that existed to house a cowboy and his horse, Pollard's Poodles Pet Supply and Hotel for Dogs enjoyed great success in early Apple Valley by housing dogs. Located between Joshua Road and Deadman's Point—the intersection and large rock outcropping at Bear Valley Road and Highway 18—Pollard's Poodles sat across the highway from McGinty's Saloon. These days, this location continues to serve dogs and their owners as Beagles and Buddies, a dog rescue facility. (Past image, courtesy of Town of Apple Valley.)

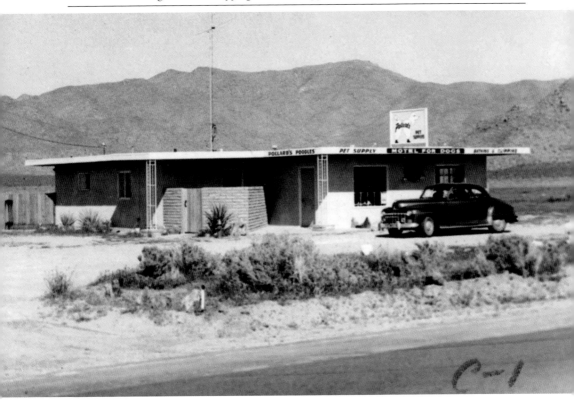

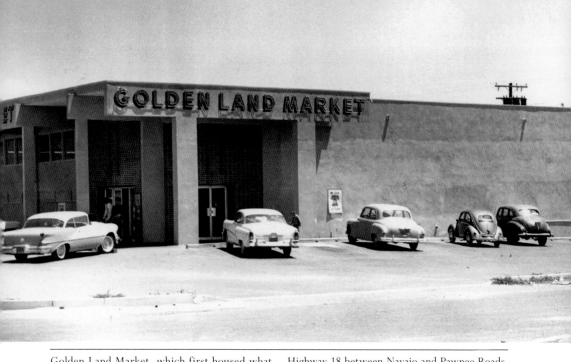

Golden Land Market, which first housed what exists today as Bank of America, shares its name with Newton Bass's Golden Land Farms horse-breeding facility, located at the opposite end of Apple Valley. This building's next incarnation was as Harwick's Market. Located on South Outer Highway 18 between Navajo and Pawnee Roads, Golden Land Farms sat within a few miles of Bass's Brahma bull farm, the Hidden Valley Stock Ranch, which was Apple Valley Inn's meat supplier. (Past image, courtesy of Town of Apple Valley.)

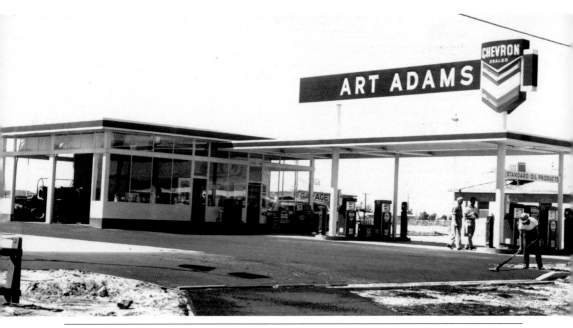

Art Adams Chevron gas station is only one of more than a dozen long-running and well-frequented gas stations in the area. Art Adams's shop was located west of the James Woody Community Center between South Outer Highway 18 and Navajo and Yakima Roads. This gas station, and those like it, offered service station attendants who washed windows and checked oil and tire pressure while filling a car's gas tank. They also operated garages offering a variety of repair services, including tire sales. (Past image, courtesy of Town of Apple Valley.)

Barely recognizable now, the Gus VanderHaegen Real Estate office stood directly west of Hugo's Liquor. That office is located two lots east of Navajo Road and South Outer Highway 18. During its time, the VanderHaegen Real Estate company was quite successful. Ironically, its location is directly across the street from the former office of Apple Valley Ranchos, now Rite Aid, which demolished the original office. Today, this complex holds three separate businesses. (Past image, courtesy of Town of Apple Valley.)

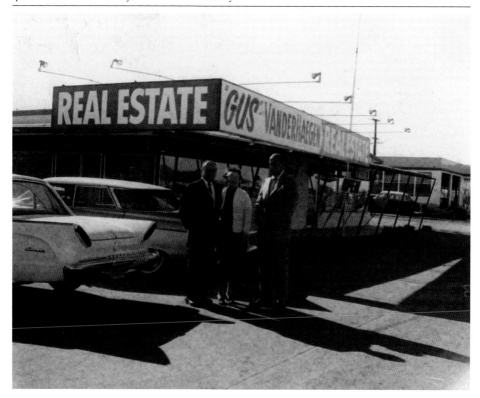

This Crippens ambulance driver stands with his rig, No. 611, at the west end of Apple Valley. On the far right, behind the ambulance, there is a small view of the Apple Valley Airport's main terminal. Today, this photograph would be shot near Lions Park, which is located at South Highway 18, east of the Apple Valley Inn. Lions Park is an Apple Valley gathering place known to host annual community events like summer concerts and flea markets. (Past image, courtesy of Town of Apple Valley.)

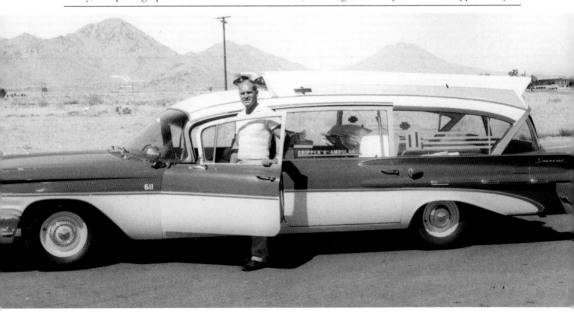

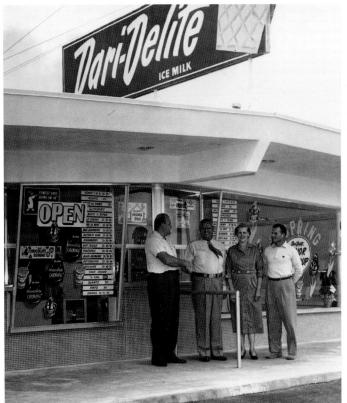

Dari-Delite Ice Milk was an ice-cream lover's dream. Featuring oodles of chocolate- and caramel-covered treats, this business was listed on a 1960 chamber of commerce map. Located on North Outer Highway 18 just east of the Lynn Building, which was now home to Desert Knolls Pharmacy and was once Desert Knolls Bakery, this fun little shop is now demolished and replaced with a regular strip mall business offering donuts and baby ultrasounds. (Past image, courtesy of Town of Apple Valley.)

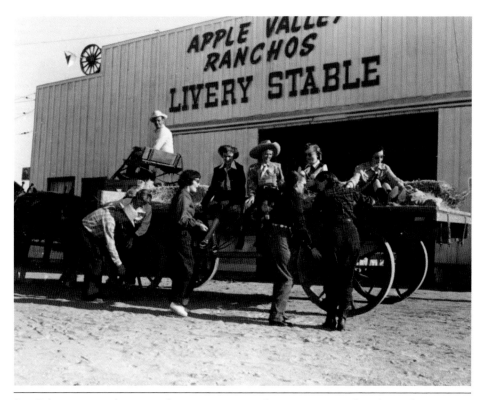

Stan Polson sits atop this wagon, happy to see a group of women getting on the hay wagon that is prepared for a nice afternoon ride, likely about 3:00 p.m. The group is probably part of a special women-centric group, like the Women's Club, though no documentation exists to define this ride's members or destination. Located on the southwest corner of Central Avenue and South Outer Highway 18, this property's current owners are in the process of removing this infrastructure. (Past image, courtesy of Town of Apple Valley.)

BACK AT THE RANCHO

Horseback riding is central to the Apple Valley lifestyle. The community was designed to accommodate and encourage equestrian lovers. Apple Valley had its own horse clubs that made their mark through the years. Among them are the Sage Riders, the Dancing Hooves, and 4-H. (Past image, courtesy of Town of Apple Valley.)

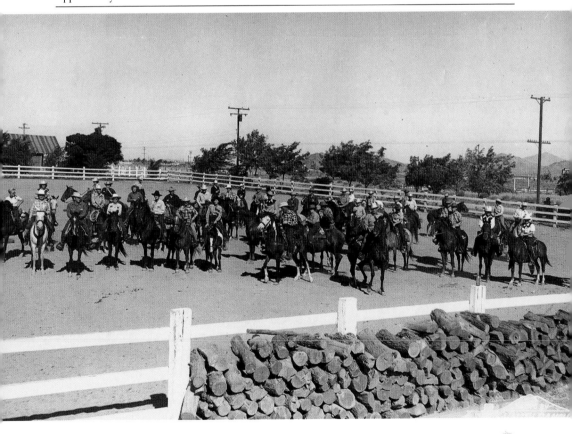

These equestrian riders appear to be preparing for a Pow Wow Days parade on Navajo Road; it will then proceed west on Highway 18. Judging from the background, this parade took place early in Apple Valley's town life. The Apple Valley Ranchos building is at the center right-hand side, and the El Pueblo Shopping Center is on the far right. This corner was made and remade repeatedly, and now it is a mainly vacant concrete eyesore. (Past image, courtesy of Town of Apple Valley.)

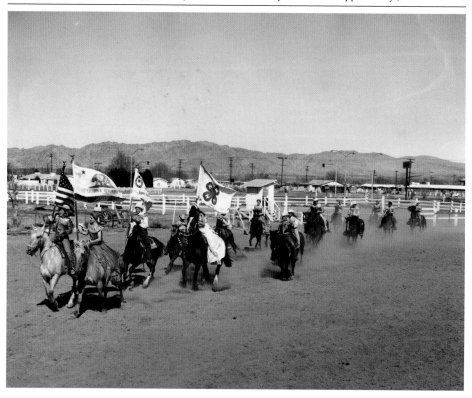

BACK AT THE RANCHO

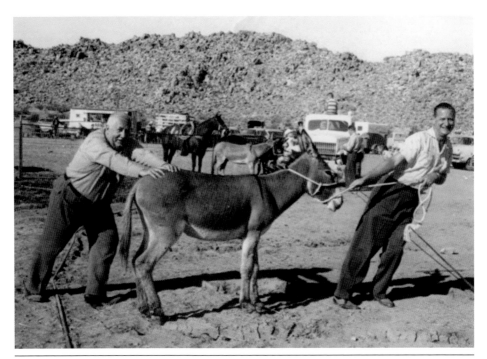

Two unfortunate race participants push this stubborn donkey during one of Apple Valley's early Pow Wow Days Burro Derby. These two men in business attire appear to be having tremendous fun, regardless of being misappropriately dressed. The Burro Derby was one of the community's annual summer Pow Wow Days events. Few would recognize that this event took place in what is the empty lot between Walmart and the Buffalo Trading Post on South Outer Highway 18, just west of the Apple Valley Inn. The race was a three-day event. (Past image, courtesy of Town of Apple Valley.)

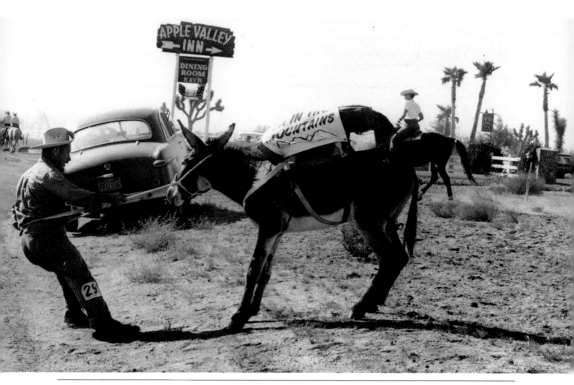

This unlucky cowboy struggles to pull an insistent burro onto the "racetrack" so he can begin his trek to the race's finish line in Big Bear. The annual race stops and rests at Deadman's Point, then proceeds through Lucerne Valley and into Big Bear, where the race participants celebrate the mountain berg's annual Miner's Day. Local businesses are handsomely rewarded with tourism money each time the race comes through town. (Past image, courtesy of Town of Apple Valley.)

BACK AT THE RANCHO

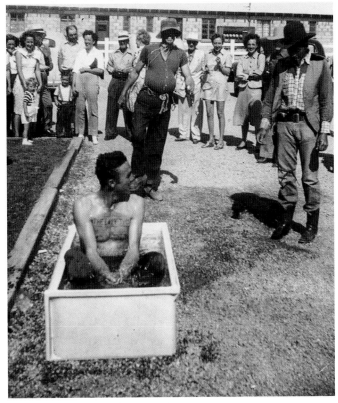

Pow Wow Days, now known as Apple Valley Frontier Days, was produced by the Apple Valley Chamber of Commerce. This photograph of a volunteer from the Lazy Two, a drugstore located in the El Pueblo Shopping Center, was taken from the back of the Black Horse Motel, a common gathering spot. The Black Horse featured rooms for humans and their horses. The building behind this man is the original Black Horse, possibly the stables that were converted to rooms and then converted again later. (Past image, courtesy of Town of Apple Valley.)

Little information is known about this group of 1950s riders other than their photograph was snapped at the southwest end of an outcropping at the Apple Valley Inn. A paved road ran close to the area and appears to have linked the Apple Valley and Rancherias Roads on the opposite side of the inn's grounds. Newton Bass's home was conveniently located near the end of that roadway. (Past image, courtesy of Town of Apple Valley.)

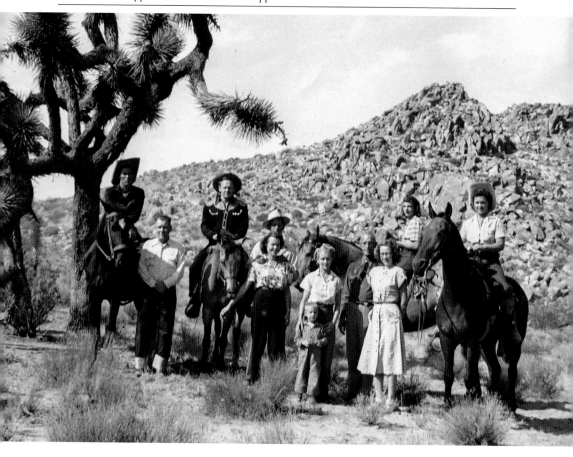

BACK AT THE RANCHO

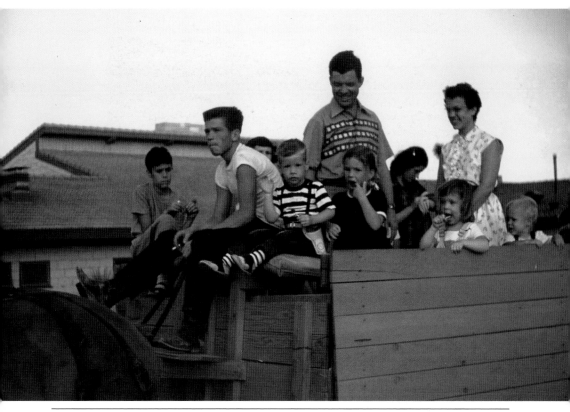

From the day it opened, the Apple Valley Inn drew countless movie crews. A.W. Bayer, a cameraman, was one of them. This photograph, shot during the 1950s, shows a happy three-year-old Chris Bayer waving while his mother and father watch. The Bascom family ran the Roy Rogers Apple Valley Inn stables when he took over in 1965. The Bascoms are a longtime, well-respected local family whose children took turns leading these rides. (Past image, courtesy of A.W. Bayer.)

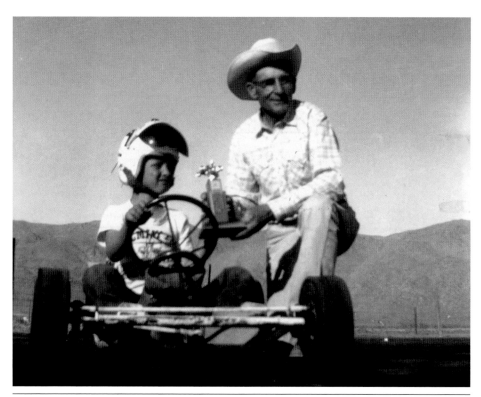

Mike and Lucille Dressler were the first couple to develop the idea of creating a tourist destination at Deadman's Point, which is located in east Apple Valley and meets at the intersection of Bear Valley Road and Highway 18. Dressler built a go-kart racing arena and a frontier town at the junction.

Legend says that Deadman's Point was named after a Big Bear miner who missed his Victorville bar ride back to the mines and decided to walk to Big Bear and was later found dead at the intersection. (Past image, courtesy of Town of Apple Valley.)

BACK AT THE RANCHO

Former owners Mike and Lucille Dressler leased the Deadman's Point Frontier Town Village to Wilfred and Donna Pierson from 1965 to 1968. The 40-acre Deadman's Point entertainment property was well known and featured shops, a café, bar, grocery, camping, dancing, its own newspaper, and go-kart, motocross, and automobile racing. The village was a hot spot for bands and drew scores for Easter Sunday sunrise services. The frontier town offered good old-fashioned fun in a good old-fashioned environment. (Past image, courtesy of Town of Apple Valley.)

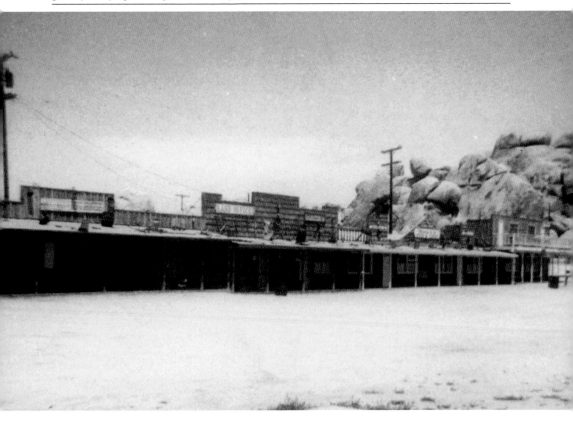

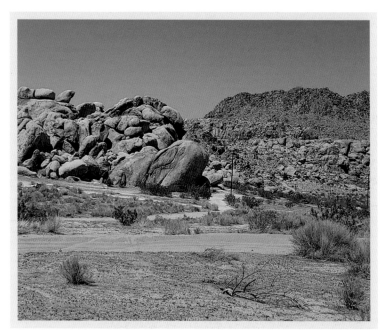

The village's racetrack was popular with go-karts, motocross, and car racers, hosting hundreds of races through the years. In 1965, the track hosted a Porsche slalom race with five different class divisions, including one for women. Many other sanctioned car slalom races followed. Sanctioned motocross events drew campers and participants to the area for years, at least through the 1970s. A special dirt motocross track was etched into the desert floor and served to challenge and defeat many racers in its time. (Past image, courtesy of Town of Apple Valley.)

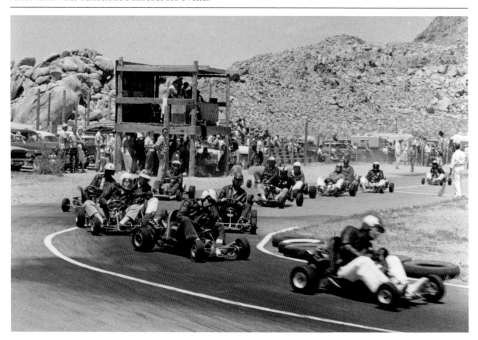

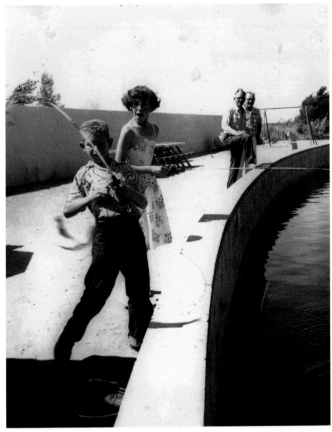

Using his water rights, Stoddard Jess built a series of 19 impound lakes. He raised two million Royal Coachman brand trout per year. Live and dressed trout were delivered to Southern California markets. In April 1955, he opened angling ponds, charging a $1 fee, plus 35¢ per caught fish. No limits, no license required. The water, fortified by fish by-products, was a nutrient-rich irrigation source for the 1,500-acre ranch. Jess produced fish pellets from his alfalfa and grain. (Past image, courtesy of Town of Apple Valley.)

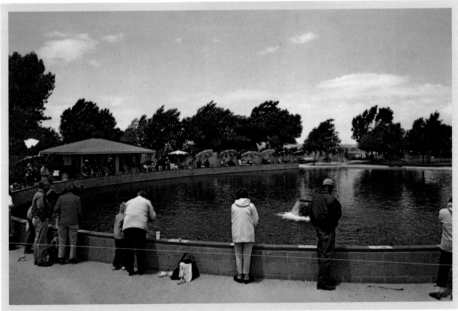

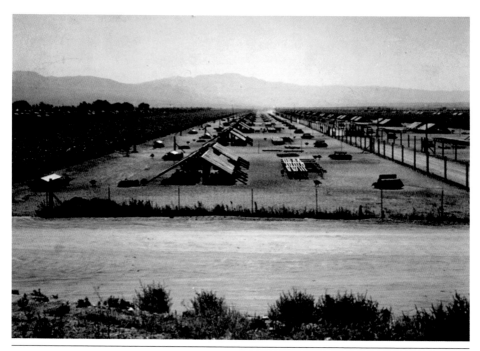

From a modest start with 200 birds, Jess Ranch developed into one of the largest integrated turkey ranches in the western United States. The ranch had its own hatchery, with a capacity of 80,000 eggs per setting. People could buy eggs, poults, and meat birds. Eighty thousand turkeys were processed per year. The 50-year operation employed many locals, who raised the birds from eggs and then processed, packaged, and shipped them to consumers throughout the southland. (Past image, courtesy of Stoddard Jess family.)

Stoddard Jess stands in front of the scales at the entrance of Jess Ranch Turkey Farm as a truck loaded with feed pulls either onto or off the farm. In its heyday, the turkey farm's largest, most imposing building was a processing mill used to make feed for the farm's livestock. The remainder of that scale and scale house still exists inside the locked gates of the exclusive Jess Ranch 55-plus senior living community that now inhabits the former Jess Ranch property. (Past image, courtesy of Stoddard Jess family.)

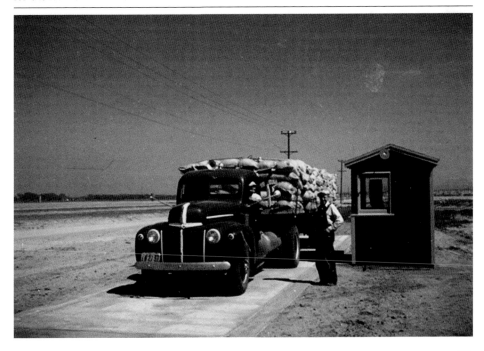

Discover Thousands of Local History Books Featuring Millions of Vintage Images

Arcadia Publishing, the leading local history publisher in the United States, is committed to making history accessible and meaningful through publishing books that celebrate and preserve the heritage of America's people and places.

Find more books like this at
www.arcadiapublishing.com

Search for your hometown history, your old stomping grounds, and even your favorite sports team.

Consistent with our mission to preserve history on a local level, this book was printed in South Carolina on American-made paper and manufactured entirely in the United States. Products carrying the accredited Forest Stewardship Council (FSC) label are printed on 100 percent FSC-certified paper.

MADE IN THE USA